CW00539230

DUNCANSBY HEAD TO THE SOLWAY FIRTH

Mike Smylie

AMBERLEY PUBLISHING

Acknowledgments

Photographic books such as these are as much about the visual as the writing and therefore an author assumes the greatest gratitude to those who supplied the quality photos. Although some come from my own collection, many do not and therefore I am especially indebted to Michael Craine, Edward Valentine, Angus Martin, Finley Oman, Willie Crawford, Charles McLeod, Campbell McCutcheon, Peter Lambie, Arthur Roberts, Rosemary Galer and The Scottish Fisheries Museum and the other individual members of the 40+ Fishing Boat Association, whose names I cannot remember, for their contributions.

General Note to Each Volume in This Series
Over the course of six volumes, this series will culminate in a complete picture of the fishing industry of Britain and Ireland and how it has changed over a period of 150 years or so, this timeframe being constrained by the early existence of photographic evidence. Although documented evidence of fishing around the coasts of these islands stretches well back into history, other than a brief overview, it is beyond the scope of these books. Furthermore the coverage of much of today's high-tech fishing is kept to a minimum. Nevertheless, I do hope that each individual volume gives an overall picture of the fishing industry of that part of the coast.

For Ana and Otis

First published 2013

Amberley Publishing
The Hill, Stroud
Gloucestershire, GL5 4EP

www.amberley-books.com

Copyright © Mike Smylie, 2013

The right of Mike Smylie to be identified as the
Author of this work has been asserted in accordance
with the Copyrights, Designs and Patents Act 1988.

ISBN 978 1 4456 1452 6
E-BOOK ISBN 978 1 4456 1466 3

British Library Cataloguing in Publication Data.
A catalogue record for this book is available from
the British Library.

Typeset in 9.5pt on 12pt Celeste.
Typesetting by Amberley Publishing.
Printed in the UK.

Introduction

Excuse the pun, but the west coast of Scotland is a very different kettle of fish to that of the east coast. Here small crofting communities sit upon the fringe of the sea, hidden among the lochs and islands that indent this sublimely beautiful littoral.

Thus fishing, in comparison to the east coast, was a mere shadow in terms of export. Mostly it was at a subsistence level where it supplemented crofting. In general it was only the herring that was sold into markets both at home and abroad, and this from only a small number of ports. Even this never reached the same proportions as that of the east coast, though harbours such as Stornoway, Castle Bay on Barra, Ullapool, Mallaig, Tarbert and Campbeltown developed in the late nineteenth century from this fishery. Before this, it was the British Fisheries Society that encouraged herring fishing by setting up herring villages in Mull and Skye and upon Loch Broom. For whitefish, during the latter half of the twentieth century, two important ports grew up where boats from outside the area landed, these being Kinlochbervie and Lochinver.

Loch Fyne and the east side of the Clyde were foremost in advancing techniques in the herring fishery so that the age-old method of setting drift nets was eventually superseded by the ring-net, which was regarded as a form of trawling. However, its introduction in the 1830s/1840s was not without local arguments, which led to riots, leading in turn to eventual government legislation in which this particular form of fishing was banned. Angus Martin's book *The Ring-Net Fishermen* fully covers this period and the later developments in the fishery, and is to be recommended.

Today the herring has gone, boats seldom land into Kinlochbervie and Lochinver as they did twenty years ago and now prawns (*Nephrops norvegicus*) account for the largest sector in the fishery, with lobsters and crabs second in importance and white fish in third place. At the same

time the number of fishing boats has shrunk, due mainly to successive decommissioning schemes brought about by Europe's demand to cut the British fishing fleet. Entry into the Common Fisheries Policy in the 1970s resulted in an influence upon the British fishing industry, which once controlled some 65 per cent of the best fishing grounds in European waters. Now regarded as a common resource for all EU nations, it is the Scots who have lost most. Furthermore, out of all Scottish fishers, it is perhaps the west coast men who have seen their fortunes return to paralleling those of the hardship times of pre-1850, before the days of fishing as an industry. However, regardless of this, there are two things that can still be said of the Scottish fishing boats of the west coast: that the Loch Fyne skiffs were among the prettiest of the sailing-era boats and that the varnished ring-net boats of the Clyde were indeed the prettiest of all British motorised fishing craft.

The fishing industry as a whole can be regarded in terms of four distinct groups: the method of fishing or the Fishing Ways; the Fishing Boats used; those whose occupations are depended on fish – the Fisher Folk – and finally the homeport communities dotted Around the Coast. All these are equally significant in how the industry operates.

Fishing Ways

Given that Scotland as we know the country today has been settled for over 7,000 years, it would be surprising if the coast had not always been a source of food for those living by rivers or the sea. From the archaeological evidence gained from middens we know that fish and seafood were major parts of the diet of prehistoric man and it is presumed that the shore was the source of most of this food. Shellfish such as mussels, cockles, whelks, winkles, oysters, scallops and limpets could easily be picked as the tide ebbed. Fish could be speared in shallow water and even, as in the case with flounder, kicked from the riverbed. Storms often left fish stranded in small pools or sometimes dead on the sand. Those found in rock pools probably led early man into one of the earliest forms of active fishing in the forming of fish traps or weirs – known in Scotland as *yairs* (Scots), *cairidh* (Gaelic) and *cruives* (in the case of salmon weirs). These fish weirs consisted of low stone walls extended up with a wattle structure of interwoven hazel branches between oak posts driven into the stonework, which were the forerunners of the stake nets set even today on the beaches. The west coast was well served by fish weirs and the remains of many can be seen around the coast in such places as Loch Broom, Loch Torridon, Loch Sligachan, Loch Gairloch and the Sound of Mull, to name but a few. *Cruives* consist of wooden structures built into rivers to catch salmon as they swim upriver; their remains survive in several rivers.

Fish traps in the form of creels – or pots, laid on the seabed to catch crabs and lobsters – are not much more than an extension of the idea of fish weirs. Their use has not changed much in a thousand years and there are only few parts of the coast of Britain that do not catch lobsters and crabs.

The use of the line and hook is probably almost as old as the fish weirs. Various plants were used to produce line such as nettles and flax, then hemp and cotton. Hooks were made out of various thorns from plants before the advent of metal barbs. These became widely used to catch fish close to the shoreline.

According to Angus Martin in *Fishing and Whaling* saithe was a most common fish, otherwise known as coalfish or coley. Because of its abundance it was relied upon as a source of food as no other fish was. Not only was there plenty of it, but it was dependable in that it was always available. It was caught by rod and line and also by what was referred to as a *pock-net*, which equates simply to a bag net suspended around a metal hoop that hung down from a pole that in turn, when baited, was immersed in the sea.

It was the arrival of the net that marked a distinct change in the fortunes of fishermen. For a small bulk of material a strong barrier of a large size could be utilised. They could be easily transported and arranged in varying manners. They could also be set across bays to catch fish on the ebb, then lowered to allow fish to ingress and raised once again to catch another batch of fish

5

on the next ebb. They were highly manoeuvrable and deadly effective in the right situation.

The next obvious development in the history of fishing was the boat. Once man learned to hollow out logs or tie them together to form rafts, he was able to fish into deeper waters. Longlines were set in deeper water, baited often with shellfish with, as we've seen, cod and haddock being the favoured catch. The same applied to setting creels further out to sea.

But it wasn't until the late eighteenth century, with the Dutch fishing herring within sight of the Scottish coast and the development of the drift net, that the Scots sensed a chance to expand their fisheries. Government intervention to build a herring fishery soon resulted in the formation of the British Fisheries Society to promote the fishery. Fisher towns were built at Tobermory on Mull, Lochbay (Stein) on Skye and Ullapool on Loch Broom. Herring fishing continued, albeit on a smaller scale than on the east coast, throughout the nineteenth and the first half of the twentieth century, especially after the introduction of the ring-net in Loch Fyne in the 1830s. After the decline in herring fortunes, it was trawling for prawns and creeling that occupied the majority of fishers into the twentieth-first century.

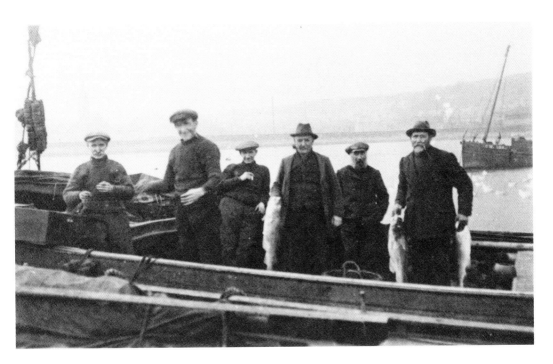

Line Fishing

Fishermen aboard the Campbeltown-registered skiff *Blue Bird* after line fishing. Line fishing was probably the most common mode of fishing. Hundreds of hooks are laid upon the seabed, fixed to a continuous line. Bottom-feeding fish were caught in this way. (*Mrs Mairi [MacIntyre] Lyon*)

Small inshore boats worked from almost anywhere along the coast. This boat was discovered in a shed on the north coast and is typical of the west-coast double-ender with sloping sternpost and rounded sections.

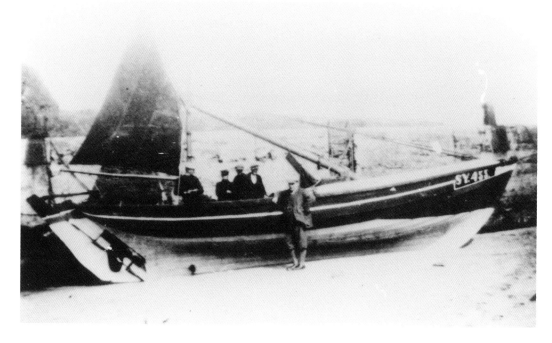

On the very tip of Lewis, in the Outer Hebrides, the Port of Ness was once home to a vibrant line fishing that was worked from this harbour. Cod and ling were caught, dried and exported all over Britain. In the late nineteenth century, when the harbour facilities were all but nothing, up to 4,000 fishermen fished in the boat they developed called a Ness *sgoth* – literally a Ness type of skiff. These boats set out north, some 40 miles offshore, and sometimes stayed out for two days line fishing.

Animal bodies were often used for buoys. Here the curator of the small Strathnaver Museum in Bettyhill, on the north coast, is exhibiting a dogskin buoy. In the islands sheep were generally used for the same purpose.

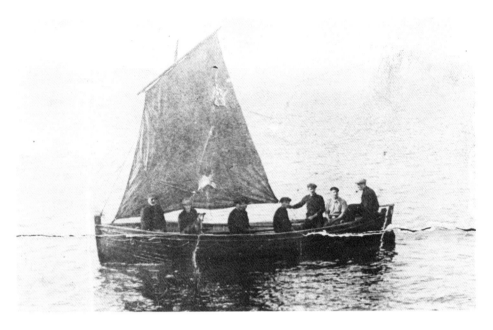

Creels

Creel boats were usually small open boats operated under sail. This clinker-built boat was typical of the small boats the fishermen sailed in, which are generally referred to as *bata*. However, they were the coastal workhorses, being used for fishing and general transport and, here, for what appears to be a pleasant sail.

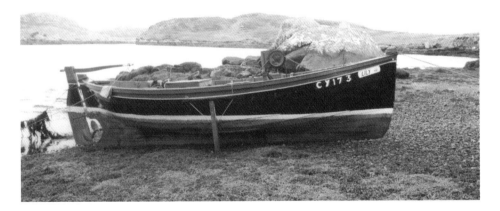

The small island of Grimsay, North Uist, has become renowned for its lobster fishery. Boats sailed to the Monach Islands, where they camped ashore for a week. These boats were built largely by the Stewart family, who originally came to the island in the 1840s from Argyllshire, bringing their design of boat with them. Boats were motorised in the twentieth century, as is this boat, *Lily*. Their design incorporated the need to ride out over surf into deeper water, sail over to the Monachs with enough gear for a week's fishing, haul creels while there and return with fishermen and the catch. The craft were renowned for their seaworthiness, their lightness and their fineness, especially at their entry, and they were double-enders (*eathar*) until the transom-sterned boats (*geola*) were built.

9

As usual, motorisation had its impact upon the type, bringing about a fuller hull shape and a transom, although some boats retained the double-ended influence that is longstanding hereabout. Five generations of the Stewart family worked until recently, and it has been suggested that they built in excess of a thousand boats. Some of the Stewart boats still survive at the fishing.

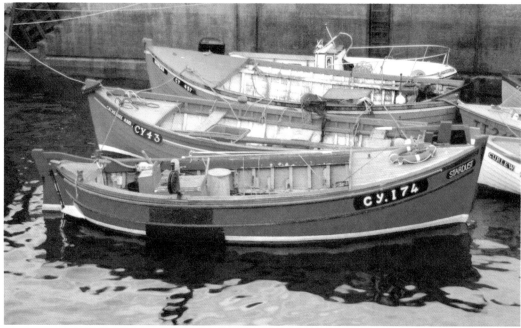

Similar boats can still be seen among other islands, such as these seen in Lochboisdale in around 2008. These worked the rich fishing grounds mainly to the east of Barra (hence they were often called Barra line boats). These small boats were up to around 22 feet long and had a single dipping lug. It has been suggested that they had been imported originally from the east coast, when it was said the east coasters sold them to the Barra men instead of sailing them home after the herring season. Many motorised versions were later built by the islanders, and further north through the Uists and into Harris. (*Mike Craine*)

Salmon

Small open clinker built and used at Portskerra for fishing salmon among other fish. A monument stands at Portskerra today in memory of the fishermen drowned nearby. Fishing remains today the most dangerous occupation, even with improved mechanisation and electronics. In the nineteenth century and earlier, disasters occurred all around Britain. In December 1848 eight men died in one disaster and in June 1890 eleven men died here in one sinking.

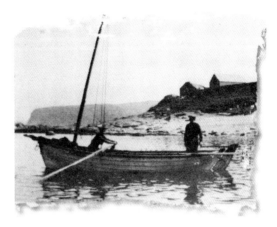

Salmon nets being dried at Castletown harbour, near Thurso. Although the harbour was built in the 1820s to export flagstones from the nearby Castlehill Quarry, today it seems to be exclusively used by salmon fishermen, who keep a couple of boats in it.

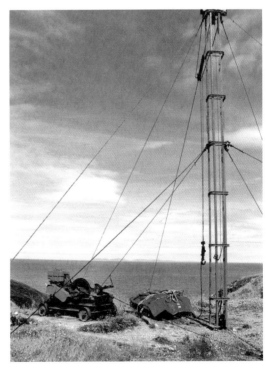

The hoist at the salmon fishery at Strathy Point. Net fishing for salmon had been exercised here for generations and at the turn of the century there were a dozen or so fishermen fishing salmon in this area. Until recently it was down to three nets operated by a father and son team. The fish has to be hauled up from the beach below the cliffs.

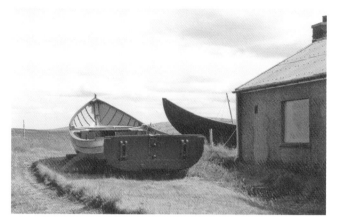

East-coast-type salmon cobles seen at the same fishery in 2003. Today they are gone. Commercially caught wild salmon are a rare commodity today as most have been kept for the anglers. Salmon farms, however, have created a huge industry and supply markets at home and abroad, with China fast outpacing anywhere else for demand.

The view down the cliffs onto the relatively sheltered slipway where the boats were landed. The type of net used was a bag net, which, once they were in the mouth of the net, led the salmon into the chamber, from which they were unable to escape.

Salmon nets drying further along the coast from Strathy in 2003, a sign that salmon fishing was still in existence in various parts of this rarely visited coast.

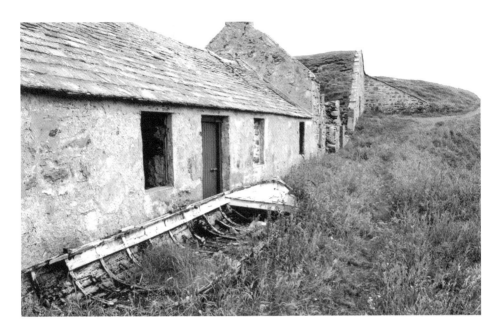

The remains of the fish house of the sweep-net fishery at Bettyhill. The building with the grass upon its roof was the ice house where ice was stored after being hacked from a nearby loch in winter. This ensured the salmon stayed fresh on its long journey by sea to Billingsgate Market. Road and train transport were used after the railway arrived in Thurso in the mid-nineteenth century. Some went as far as Paris and Vienna.

A small boat found inside the shed in 2003, though the door of the shed was locked in 2011. The fishery was operated by five men, two rowing, one on the after end ensuring the net ran out, one on shore holding the end of the net and the other watching for fish and giving the orders. The last foreman was Jock Mackay who recalled how, in July 1962, they caught 979 salmon and this all had to be handbarrowed up the hill. In the same year they caught 334 in one sweep and Jock reckoned that the same amount of fish were left behind after they finished fishing than were there when they began. Fishing ceased in 1992 after having continuously been practised since 1746. Upstream the remains of a *cruive* can still be seen.

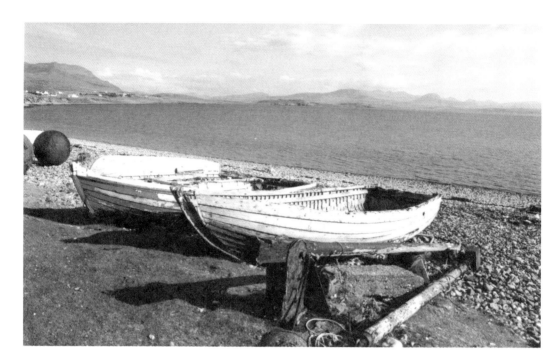

Salmon cobles drawn up on the beach at Achiltibuie in 2003. By 2011 they had almost fallen apart.

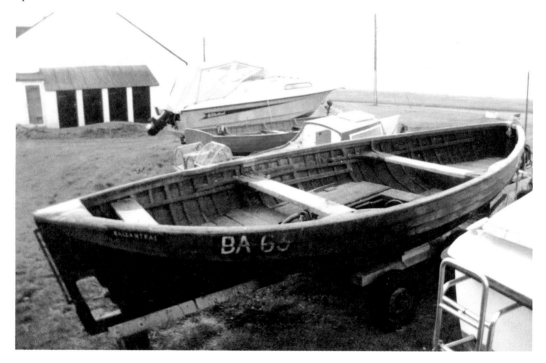

At Ballantrae on the Clyde, there was also once a healthy salmon fishery. Several boats remained ashore and this one, *Noreen*, BA63, was a typical west-coast boat that was adapted for salmon fishing.

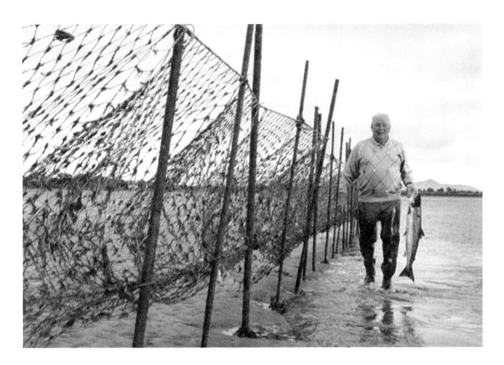

The Solway Firth is still an active salmon-fishing area. Here a salmon is being taken away from the stake nets that are set on various parts of the north shore between Annan and Creetown. They are said to date back at least 1,000 years to when the monks at Gretna fished similar nets.

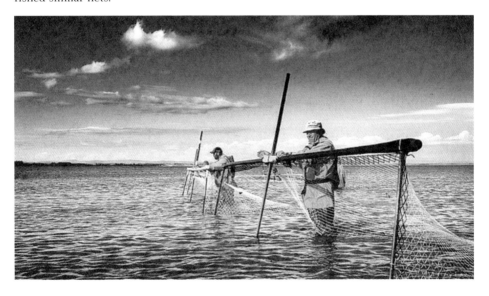

Haff nets (meaning sea nets) are mounted on rectangular frames 18 feet wide and 5 feet deep, supported by three legs. The fishermen wade out into the shallow waters of the Solway sands and place the net in front of them facing the tide. The net streams out to form a bag net and, when a salmon swims into the bag, the legs of the frame are allowed to float to the surface, thus trapping the fish, which is then killed with a blow from a wooden club called a priest or neb. Licences are severely restricted today.

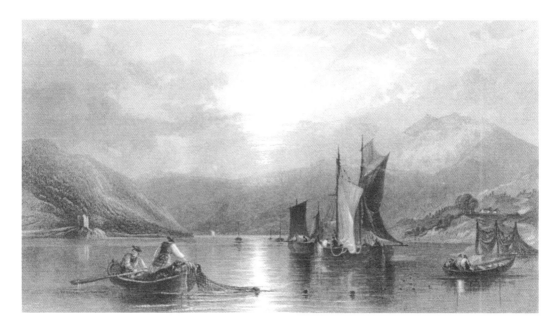

Herring

A print of 'Loch Fine' by Robert Wallis where there has for centuries been a healthy herring fishery. In 1527 Hector Boece reported that in Loch Fyne 'is mair plente of herring than is in any seas of Albion'. In 1603 Sir Walter Raleigh spoke of the Dutch selling herrings to other nations 'of £1½ million' (presumably being the value of the catch), employing 20,000 men, all Scots, and with all herring being caught on the Scottish west coast, most notably Loch Fyne.

Likewise, the herring they caught was renowned for its particularly tasty quality. Campbeltown, said to have one of the best harbours in the world, was at the centre of the 'buss' fishery in the early part of the eighteenth century. However, throughout this coast the fishing gave a seasonal alternative to working the land and an addition to an otherwise relatively monotonous diet. This branding was found in a house in Badachro, near Gairloch.

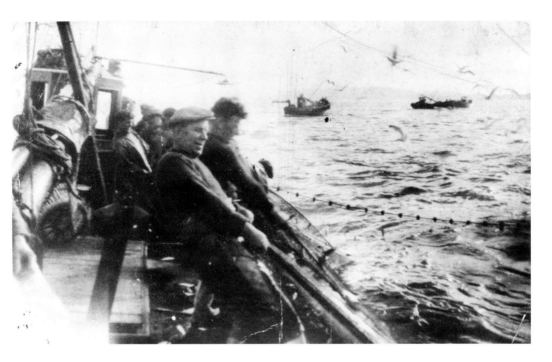

Although drift nets were originally the method of catching herring, it was the irregular use of a seine net near Tarbert in the 1830s that led to the introduction of ring-netting. Whereas drift netting is a passive form of fishing, ring-netting is active in that the shoals are sought and the net shot around them. Here the fishermen are hauling in. (Rosemary Galer)

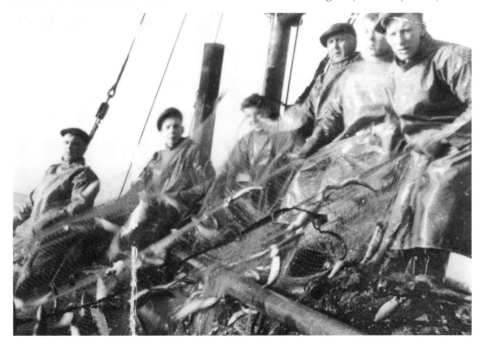

Drift nets are hauled onto the boat and the fish shaken out, as in this photograph. The waterproof oilskins used by the men can clearly be seen. (Rosemary Galer)

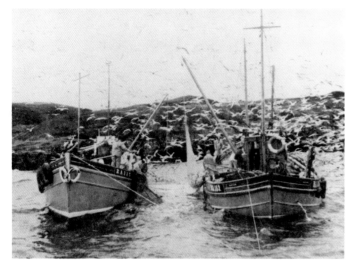

In ring-netting, two boats trawl a net and then, to complete the circle, the boats come together. Here are two well-known boats (called ringers) – *Watchful* (*left*) and *Wisteria*, both registered in Ballantrae (BA) – after they have come alongside. The photo was used to advertise the net and line manufacturers J. & W. Stuart Ltd.

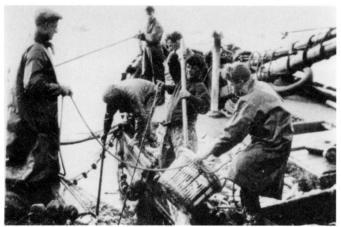

Herring is being basketed aboard the ringer *Busy Bee* off Heisgeir, South Minch, in the early 1930s. Boats travelled all over between Southern Ireland and the Outer Hebrides at different times of the year, and some went to the east coast fishing as far down as Whitby.

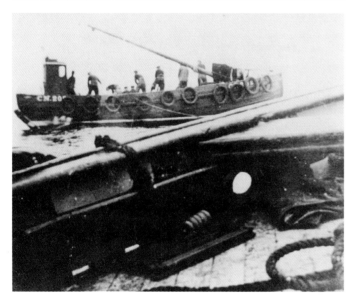

Fishing was mostly done at night, when the herring came close to the surface. However, in this photo, a daylight ring has been shot by Dugald Blair aboard the *Glad Tidings III*, CN202. The net is being hauled aboard while the towing strain is maintained by the neighbour (partner) boat.

Prawns

Prawn fishing overtook white fish and herring due to demand and decline in the herring. Here the Ayrshire boat *Numora* is seen in four different stages: First, hauling up the net.

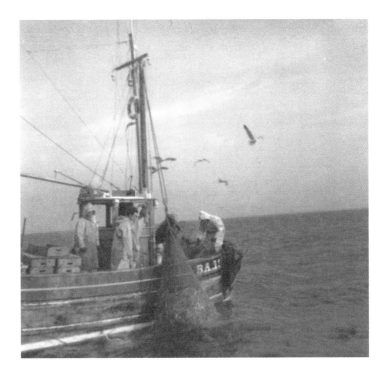

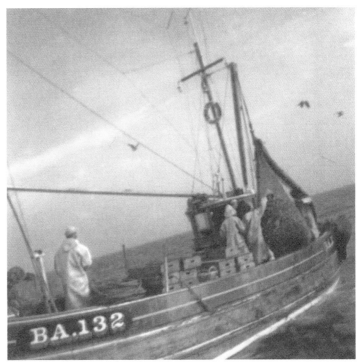

The net has been hauled aboard and the cod end is about to be opened.

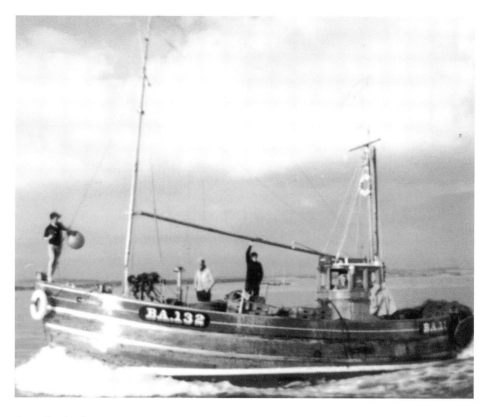

Steaming back to port.

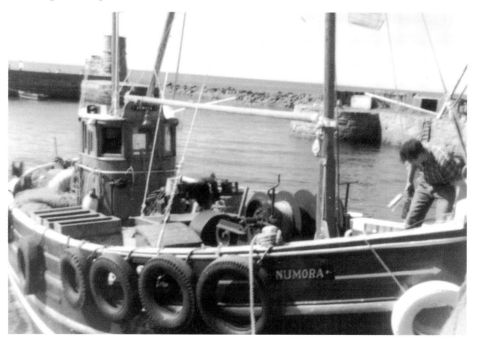

Arriving back in her home port of Dunure.

Fishing Boats

Early fishing boats were simple open boats, often constructed by the fishermen themselves using flimsy wood and poor nails, especially for the crofter/fishermen who had no access to proper resources. As already mentioned, fishing never reached the same proportions as that of the east coast though several important ports grew up where boats from outside the area landed. Fishermen from the Clyde and Campbeltown area were foremost in developing the ring-net, which resulted in the Loch Fyne skiff – generally referred to as a *nabby* on the Ayrshire coast. In time, with motorisation, the ring-net type of boat known as the 'ringer' evolved. In the second half of the twentieth century only two boatbuilding companies – Campbeltown Shipyard and Nobles of Girvan – built substantial-sized boats, while a host of small boatbuilders along many parts of the coast had been responsible for the massive explosion in the half-decked skiffs and open *bata* a century earlier. Although the Loch Fyne skiffs have been described as among the prettiest of beach boats in Britain, their successor has also been portrayed as one of the most handsome of the motorised vessels. We've already seen various types of small *bata* craft, as well as the Grimsay lobster boats and Barra line boats, all of which did (until motorisation in some cases) follow the west coast standard – double-ended, sloping sternpost, pear-drop stern – though the stem of the boat can either be sloping, as in the Scandinavian influence, or more upright as is found in the south of the region.

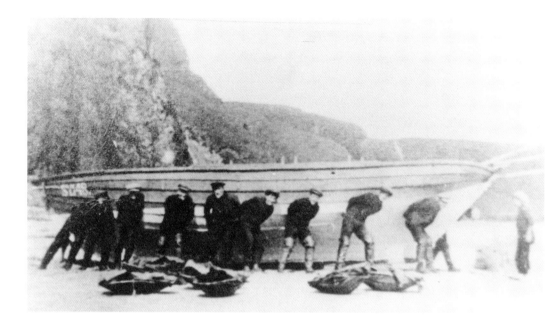

In the north of Lewis, at the Port of Ness, the *sgoth Niseach* (literally Ness-type of skiff) was the favoured line-fishing boat. Retaining its obvious Scandinavian shape, these were being built in the 1850s with a keel length in the region of 20 feet. However, by the end of the century these craft had become effective fishing machines such as this one – the *Brothers Delight* – which is being manhandled into the water from Tolsta (Port Beag) beach in 1928. Harbour facilities on the Outer Hebrides were scarce and boats were mostly beached.

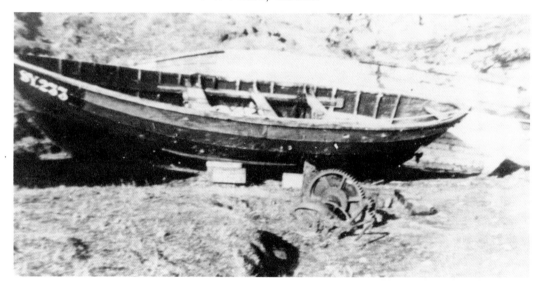

The *Jubilee*, SY233, was built by John F. MacLeod in 1935 and is a smaller version with an overall length of 27 feet. She was the last boat built and was languishing on the beach in 2003, though she was later rescued and restored and now sails under the ownership of the North Lewis Maritime Society. She is also the last sail-powered boat to have made the 80-mile round trip to the Sula Sgeir rock for the annual *guga*, where young gannets are culled, salted and brought back to Ness and sold as a local delicacy. It's an acquired taste I am assured!

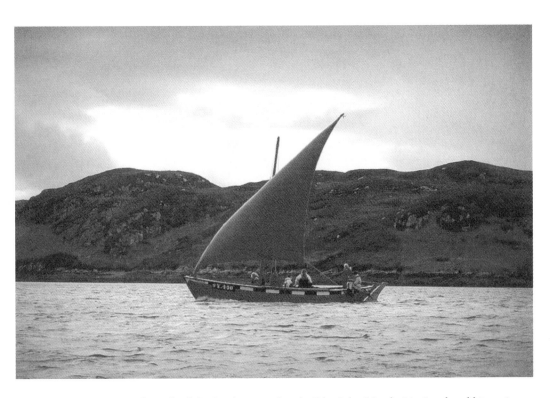

A replica Ness *sgoth* was built by local master boatbuilder John Murdo MacLeod and his assistant Angus Smith, and was launched in 1994 at Stornoway. John's grandfather was the owner of the last boatyard to build the boats commercially. Today she, like *Jubilee*, sails around the west coast.

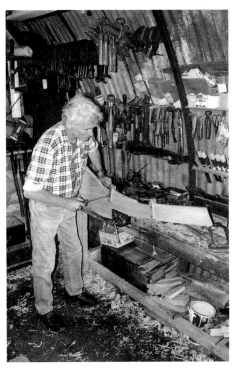

Boatbuilder John MacAulay of Flodabay, Harris, in his Nissen hut working on a new rudder in 2003. Coming from a family with generations of fishing behind them, John has been described as Scotland's best traditional boatbuilder and learned his trade during his five-year apprenticeship at Sir Charles Connell's Scotstoun yard, gaining his trade certificate in the early 1960s. Afterwards he worked for several years on fishing boats and commercial craft in Oban, Kyle of Lochalsh and other parts of the west coast. He was after all, as he himself says, 'brought up with wooden boats'. He has since retired.

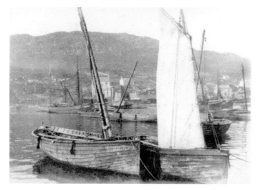

On Loch Fyne small line skiffs had worked drift nets as well as line fishing out of the herring season. Lug-rigged trawl skiffs were adapted purely for ring-netting and these seem to have been introduced into the area from the Ayrshire coast. These two are at Tarbert in about 1880 and a Clyde smack, a type of boat common throughout the British Isles, can be seen in the background.

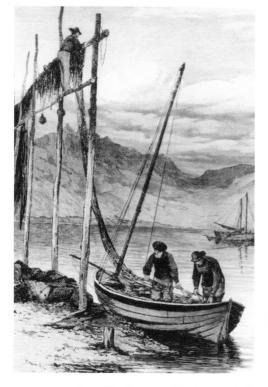

A trawl skiff at Tarbert, pre-1884. Two smacks are anchored off. Smacks tended to trawl for whitefish and seldom worked the herring fishery. The net from the skiff is being lowered back into the skiff from the net poles where it has been drying.

The trawl skiffs were always varnished and never painted, as seen in this painting by David Murray, ARA, of Tarbert harbour in about 1870. No examples of a trawl skiff remain today.

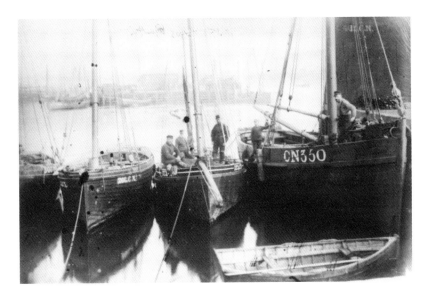

Trawl skiffs and a smack at Campbeltown. The smack is half-decked so that it is open from behind the mast to the stern. Similarly the trawl skiffs have a short foredeck with a tiny cuddy beneath, though this was too small to sleep all the crew. The numbers on the bows of the boats refer to their fishery registration. Port letters come first for first- and third-class boats, such as CN350, whereas 299CN is a second-class boat. After 1902, letters came first for all vessels.

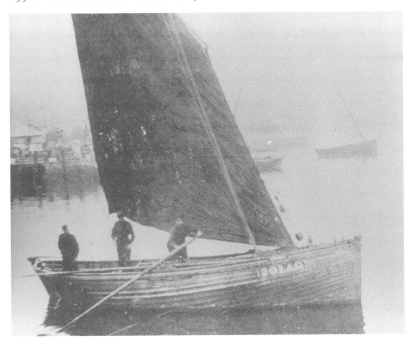

A larger trawl skiff in Ardrishaig. These boats had a raking mast, the angle of which could be altered to suit sailing: more upright when sailing with the wind but raking back on a beam reach. This was to allow the mast to be placed as far forward as possible to give deck space to work the nets.

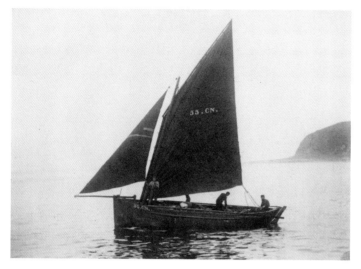

In the early 1880s a larger skiff was introduced into Campbeltown that had a larger cuddy beneath the foredeck, which allowed the fishermen room to sleep. This skiff is the *Fairy Brae*, 55CN, seen under full sail on a still morning off Davaar Island, Campbeltown Loch, in around 1890.

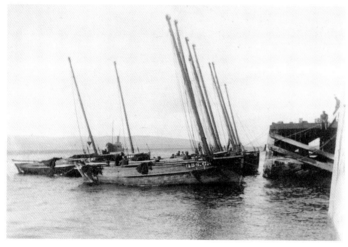

A few skiffs prepare to go to sea while moored at Loch Ranza pier, Isle of Arran, in 1910. (*Angus Martin*)

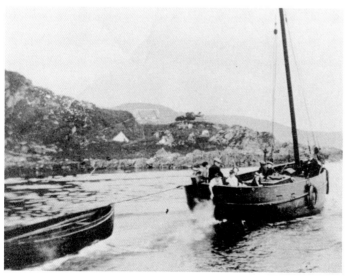

Skiffs worked under a single standing lug sail with jib until the advent of the engine. The skiff here is the *Brothers*, CN97, the first engined skiff on the west coast, belonging to Robert Robertson. She is seen here soon after having her engine installed in 1907.

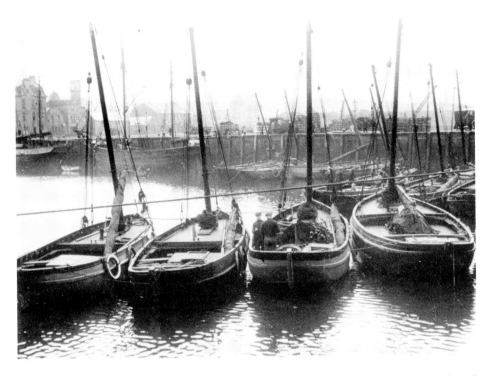

Skiffs tied up at Campbeltown in 1922. The foredeck is clearly visible and on the starboard side in the open area is the cover for the engine. Barrels of herring can be seen on the pier, alongside which are a couple of trading ketches.

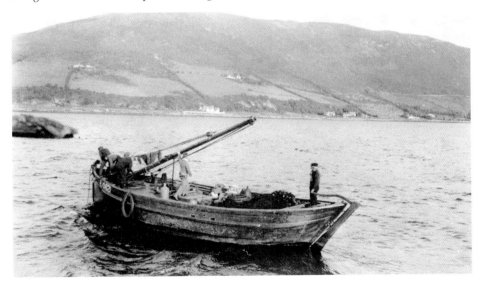

The skiff *Ella*. The crew are raising the anchor while the helmsman, standing in the stern sheets, has a clear view ahead. The net is stored immediately in front of him while the foredeck extends a fair way back in comparison to other skiffs. Note the gas bottle and the tyre of an old motor car, which the fishermen used as fenders. Five crew was normal and judging by the drying washing, they had been away from home for a few days, as was normal. (*Mrs Margaret McBride Harvison*)

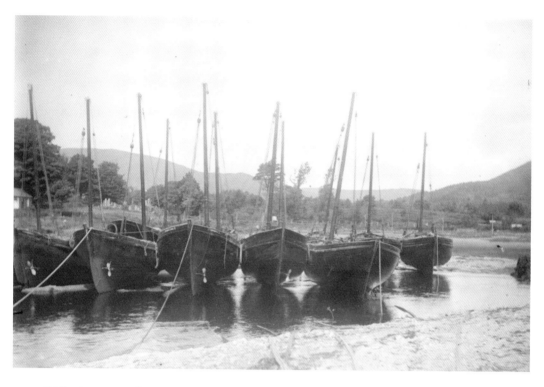

Skiffs sitting upright at Waterfoot, Carradale. The propellers all emerge on the starboard side, well away from the net, which is shot and hauled over the port side.

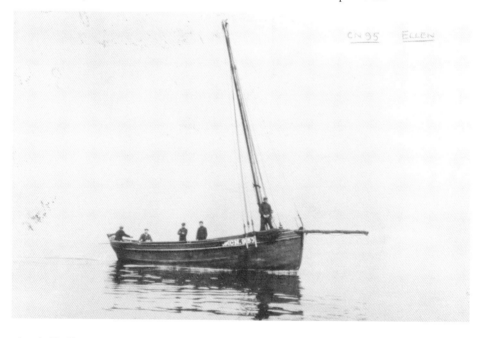

The skiff *Ellen*, CN95, returning from Hunter's Quay after having her engine installed in 1908. The skiff owners mostly favoured Kelvin engines manufactured in Glasgow by the Bergius Engine Co. (*Neil Short*)

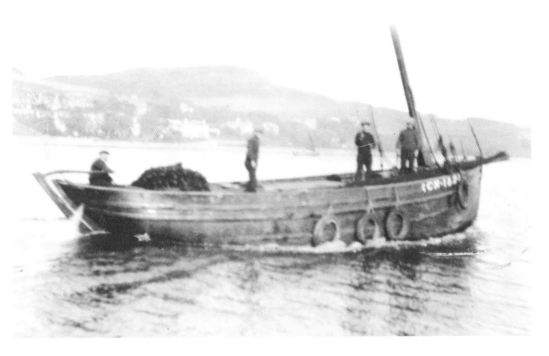

The *Ellen* was owned by Duncan Edwards and he neighboured with the 1912-built *Perseverance*, CN152, owned and skippered by Archie 'Try' Mathieson. Together the two were called 'The Desperates' as it always seemed that they were desperate to go to sea. Here the *Perseverance* is leaving Campbeltown to go fishing.

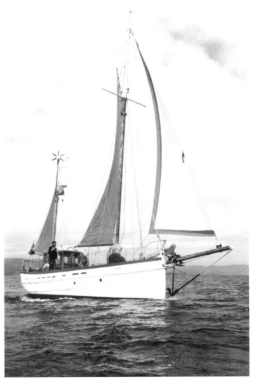

The *Perseverance* was one of a very few skiffs to survive into the later part of the twentieth century. She ceased fishing in 1951 and was eventually restored and converted to a yacht in the late 1970s before being bought by the author in 1990. In this photo she is back in Scottish waters, where she celebrated her eightieth birthday in Campbeltown in 1992. She was sold again in 1995 and sadly sunk the following year. To date there are about three skiffs still sailing.

The following photographs come from the small fishing hamlet of Minard, on the upper part of Loch Fyne. Together they tell a small part of the story of fishing.

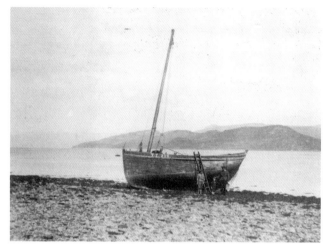

The skiff *Treasure*, TT316, sits on the shore in front of the village in about 1930. There was no harbour or pier, just the beach. (*Willie Crawford*)

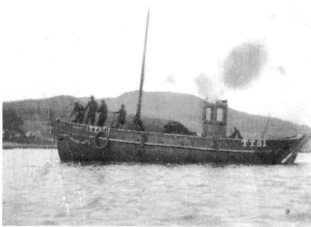

Another of the local boats was *Britannia*, TT81, built by John Fyfe of Port Bannatyne, Rothesay, in 1909. She is seen with the crew hauling in the anchor off Minard. (*Willie Cameron*)

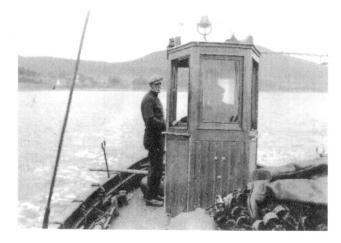

Willie Cameron stands outside the small pillbox wheelhouse with the skipper inside. The net is visible in the foreground. The skiff was fully decked. (*Willie Cameron*)

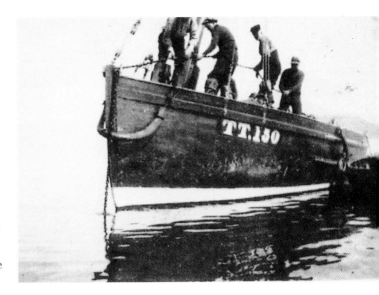

Another local boat was *Sireadh*, built by Millers of St Monans, Fife, in 1923. She was owned by A. & D. Munro, R. McGilp and J. Turner, all of Minard, and had cost £751 3s 9d. Again, she is seen with the crew hauling up the anchor.

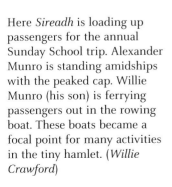

Deck view of *Sireadh*. Surprisingly, she was not built with a wheelhouse although she was engined. She was fully decked and was also used to transport family when going into nearby Inveraray, or even further afield.

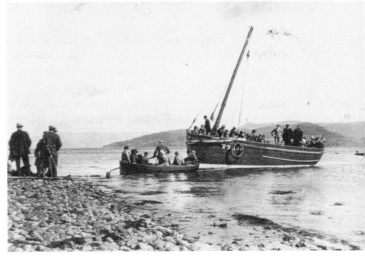

Here *Sireadh* is loading up passengers for the annual Sunday School trip. Alexander Munro is standing amidships with the peaked cap. Willie Munro (his son) is ferrying passengers out in the rowing boat. These boats became a focal point for many activities in the tiny hamlet. (*Willie Crawford*)

Sireadh ceased fishing in 1938 and was sold to Belfast and became the yacht *Golden Plover*. She eventually was sold to the South Coast of England, restored and sailed to the Canaries under her original name. Today she is undergoing another full restoration near Dartmouth.

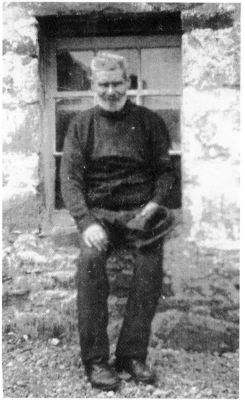

Part owner/skipper Robert McGilp (1862–1931).

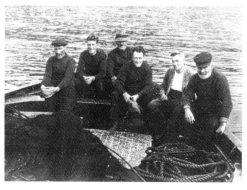

Crew sitting on the stern of *Sireadh*.

This series of photographs comes from the small hamlet of Inveralligin on the north side of Loch Torridon, where a small boatbuilding family lived and worked.

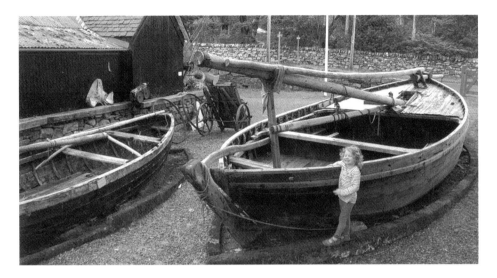

The skiff *Queen Mary*, UL138, was built by Murdo McDonald and his son Donald at Inveralligin in 1910 at a cost of £62. At 31 feet overall, she had been built from larch and elm brought across from the Ben Damph forest and cut by their own bandsaw. She was similar in design to the Loch Fyne skiffs and sailed down to the Clyde to join in the herring fishery in some years. Out of the herring season she line fished from Badachro for cod. Today she is an exhibit at the Gairloch Heritage Centre, where this photograph was taken in 2011.

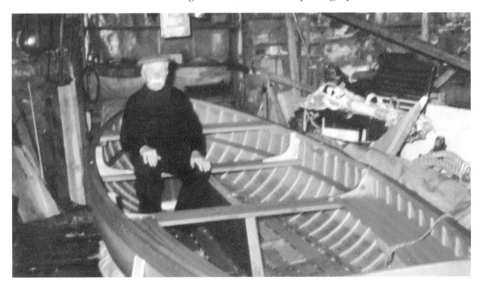

Murdo McDonald was the first generation of his family to build boats at Inveralligin. Two further sister boats to *Queen Mary* were built: *Lady Marjorie* and *Isabella*. His grandson, another Murdo, continued as the last member and here he is seated in a small clinker centreboard sailing boat he had built.

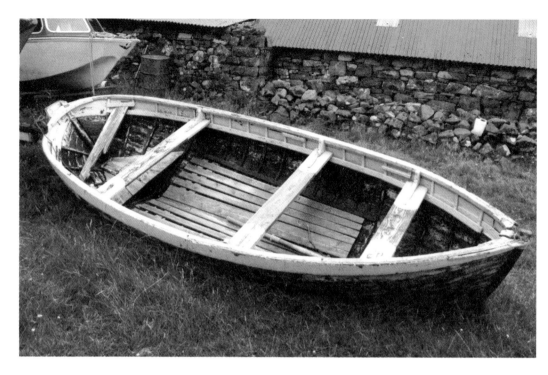

A small *bata* built by McDonalds and lying at Inveralligin in 2002. Murdo eventually went to Papua New Guinea to teach boatbuilding skills, before returning and retiring.

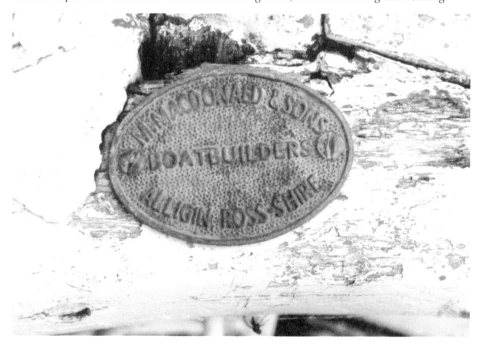

Detail of the builders' plaque aboard this *bata*.

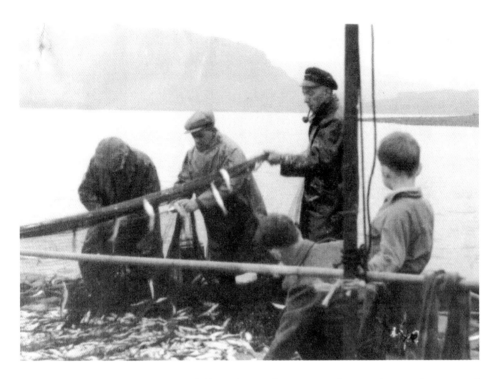

The McDonalds also went herring fishing during the season, when a substantial amount of money could be earned to supplement an otherwise poor income. Here they are shaking herring from their drift nets.

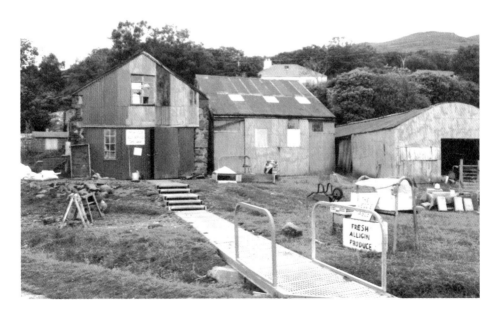

The McDonald boatbuilding shed in 2002. The family was long gone and the shed was home to a sort of 'self-service' shop selling local eggs from the hens that ran around our feet, and vegetables from 'The Veggie Table'.

This series of photographs follows the fortunes of the skiff *Clan Gordon.*

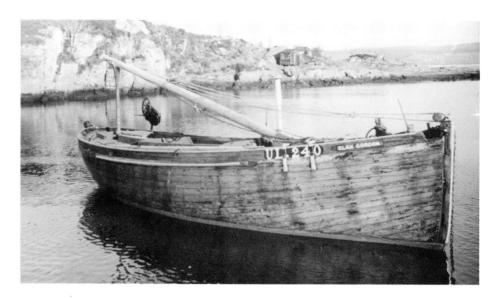

The *Clan Gordon* was built in Ardrishaig in 1911 and originally registered BRD121. She was fished by the Gordon family of Kishorn. Not much is known about her early history other than that her registration was changed to UL240, as in this photo, taken near Ullapool. (*Charles McLeod*)

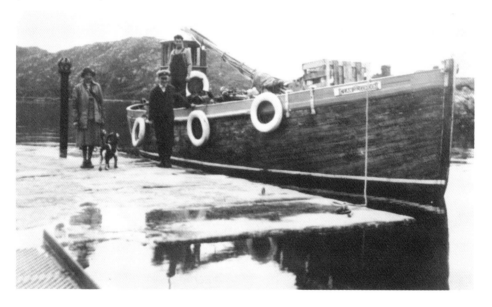

By 1958 the boat was owned by the Northern Lighthouse Board. Based in Portree, she was used to service the Rona lighthouse, taking lighthouse keepers and their supplies back and forth. Skippered by Charlie McLeod, the crew consisted of his brother and one other. A wheelhouse had been added by the time this photo was taken alongside the Rona quay in around 1960. (*Charles McLeod*)

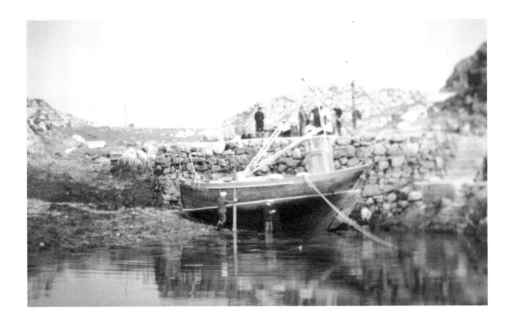

Another photo – this time in colour – of her alongside the Rona quay. The extreme shape of the skiffs is clearly obvious: deep heel, sloping keel, shallow forefoot and raking sternpost. The underwater shape made the boat very manoeuvrable for ring-netting and the keel is kept to the shortest length as harbour dues were paid on its length. But it was a lovely shape! (*Charles McLeod*)

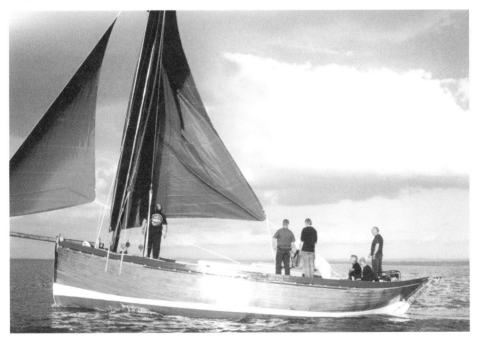

Finally, a photograph of her sailing with the author aboard in 2000 in the Firth of Forth. After that the boat moved back to Ullapool and sadly sank in 2011; it is under repair/restoration in Ullapool.

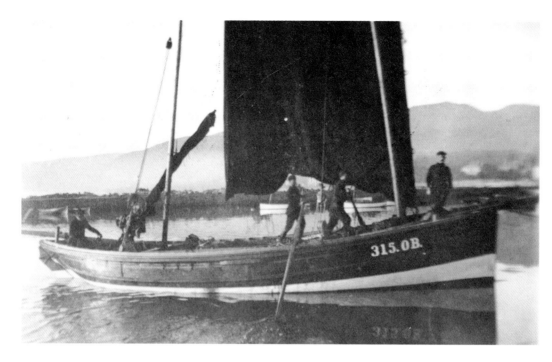

We've lingered over the skiffs and it's time to see what other boats worked the west coast. Here is a small Zulu from the east coast in the first decade of the twentieth century. The *Jeannie*, 315OB, was owned by Alexander Yule from Tobermory and he had brought the boat and his family from Peterhead. (*Mull Museum*)

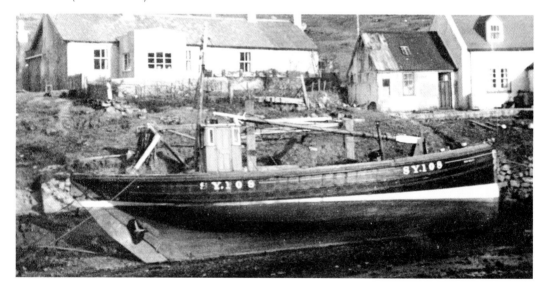

In Volume One, mention was made of the Zulu *Muirneag* that ended up as fencing posts in Lewis. Here then is another Zulu in Lewis in 1949, *Try Again*, which was originally registered as INS132. Many of the east-coast boats ended their days on the west coast after the east-coast fishers adopted steam drifters. Steam didn't have much impact on the local fleets although steam drifters and trawlers owned away worked the fishing grounds offshore. For ring-netting steam made no impact and it wasn't until the 1920s that boat design altered.

Photographs of ring-netters from around the Clyde.

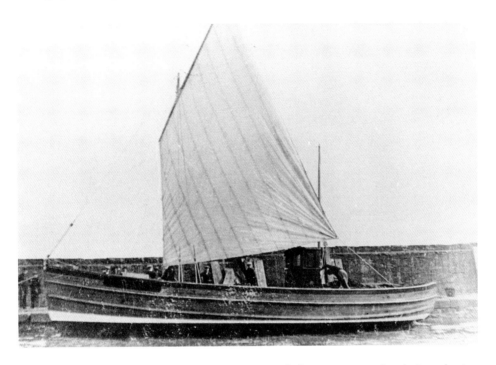

In 1922, the first of a new breed of boat arrived in Campbeltown – announcing the introduction of the motorised ring-net boat, or ringer. However, the first, *Falcon*, followed closely by the second, *Frigate Bird*, still set a lugsail as the engines were still relatively unreliable and deemed to break down. These two boats were designed by renowned Glasgow naval architect W. G. McBride at the instigation of fisherman Robert Robertson, who had previously been the first to install an engine into his boat. The design, with a canoe stern, was influenced after Robertson visited Sweden. The boats were built by James Miller of St Monans and proved successful even if others doubted their capability at first. Soon many more arrived. (*Angus Martin*)

Glen Carradale, CN253, was built by Walter Reekie of St Monans in 1933. She fished for herring with the ring-net, neighbouring *Fairy Queen*, CN128, *Nobles Again*, CN37, and *Golden Fleece*, CN170. She was sold to Lochbuie, Mull, in 1955 and the registration was cancelled in 1962. This photo was taken in 1979 but by the following year she had become abandoned at Lochaline, where she gradually fell apart. In 2001 both the stem and sternpost were lying flat although the hull planking retained some degree of shape. During a field trip with other members of the Scottish Institute of Maritime Studies, the author undertook a study of the wreck and drew up a plan.

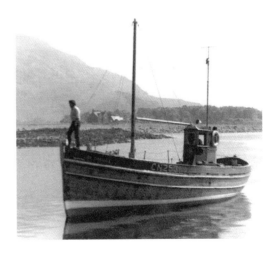

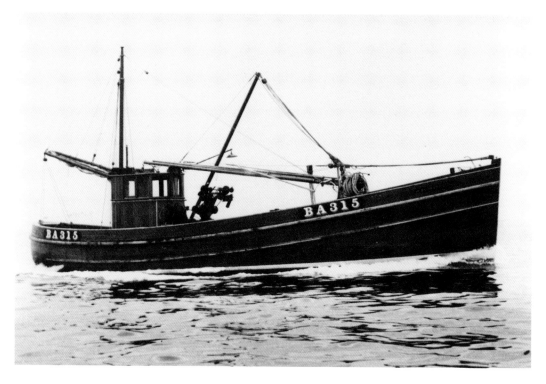

Bairn's Pride, BA315, was built by James Miller of St Monans in 1948. She later moved to Kintyre under the registration CN71.

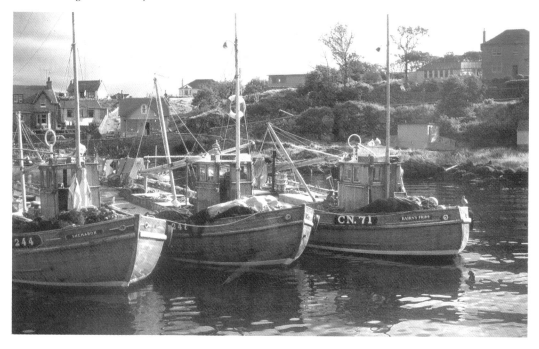

Here are *Bairn's Pride* and *Shemaron* at Carradale in the 1960s. Moored in between is the ringer *Fair Maid*, CN248.

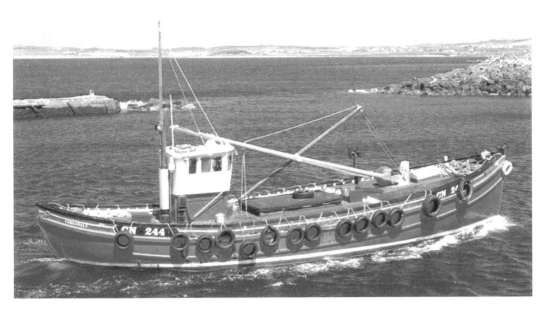

Shemaron, CN244, was built by William Weatherhead in Cockenzie in 1949 as *Wistaria*, owned by the Sloan Brothers of Maidens until she was sold to Carradale and renamed *Shemaron*. She was a successful boat at the ring-net, but after the decline in the herring was rigged for scallop fishing before being retired from fishing in 2006. She is now privately owned and well looked after as a prime example of these wonderful boats. (*Finlay Oman*)

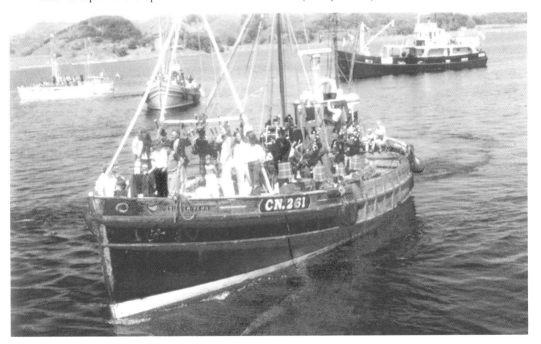

Silver Fern was built by the Fairlie Yacht Slip Ltd in 1950 and owned by Andy McCrindle as BA101. She was later registered as CN261, as she is here. I found this photo among those of my father after he died and think it was taken at the Crinan Oyster Festival in about 1975. The boat eventually went to Cornwall in 1979 and later to Fleetwood, where she was decommissioned in 2001.

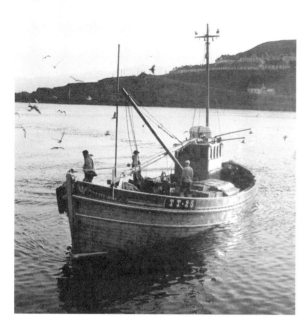

Village Maid II, TT25, was built in Ayrshire by James Noble & Sons in 1961. She has been described as 'arguably the finest ring-net model of her time' by Brian Ward and was another example from Noble's yard in Girvan. She is renowned as being the first Tarbert boat to carry a life raft atop the wheelhouse. After moving to Mallaig in 1990, she was decommissioned in 1994.

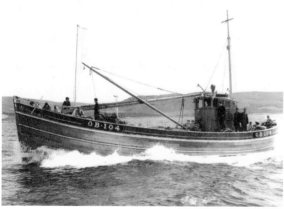

Crystal Sea was built by Alexander Noble, OB104, of Girvan in 1963. She moved to Campbeltown in 1979 and later to Northern Ireland in 1989. She was decommissioned in 1996.

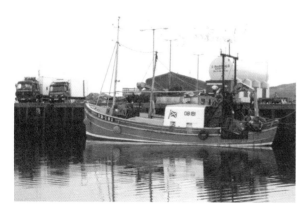

Pathfinder was built by Alexander Noble in 1964 as BA252. She was owned by Ayrshire skipper Bert Andrews and neighboured with *May Queen*. Here she is rigged as a trawler, though originally she was a dual-purpose seine net/ring-net boat. She was registered OB181 in 1973. The photo was taken in Campbeltown in around 2003.

This is a series of photographs taken in Ullapool in the 1950s/1960s (all these photos are from Peter Lambie). All the boats were based on the east coast except *A'Mhaighdean Hearrach*, which was built and kept on the west coast. They illustrate the type of boat from that era.

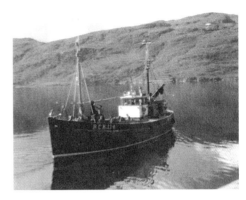

Crimond, BCK118, built as a herring drifter, coming into Ullapool.

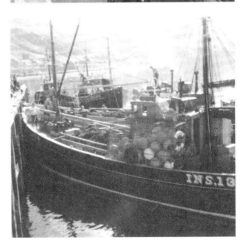

Crimond, deck view, alongside the inside of the pier at Ullapool.

Narinia, INS134, alongside Ullapool's pier.

A'Mhaighdean Hearrach (the Maid of Harris), SY824, renowned for being the vessel carrying conservationist Dr J. Morton Boyd when he scaled the cliffs of St Kilda in 1959.

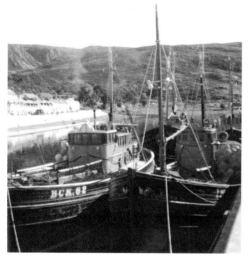

Lily Oak, BCK82, alongside *Narinia*, INS134, at Ullapool.

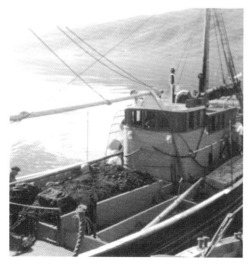

Lily Oak, deck view.

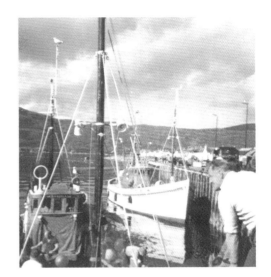

Fragrant Rose, BCK64. Built by Herd & Mackenzie in 1957, she was a seiner.

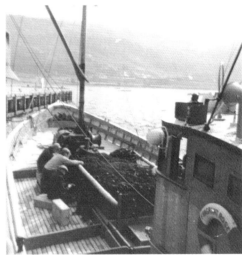

Fragrant Rose deck view, showing her gear.

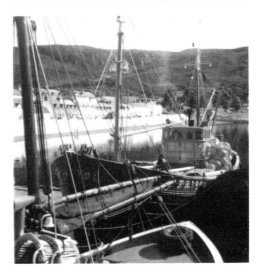

Bdellium, FR185. She was lost at sea with her crew in 1962

These are photographs of boats working the Ayrshire coast.

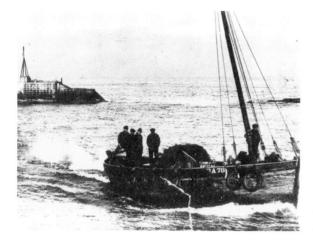

Although almost identical in shape to those from Loch Fyne, skiffs on the Ayrshire coast were called *nabbies*. Here is *Aliped 1*, BA78, under power with her ring-net clearly visible.

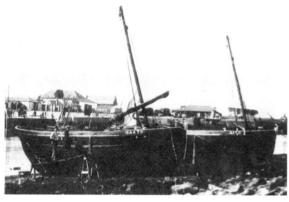

Two nabbies on the shore at Girvan, on what is now the site of Alexander Noble's yard.

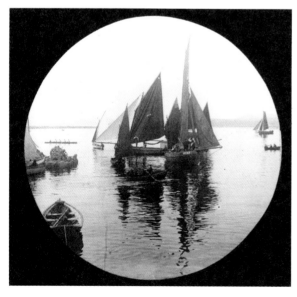

Regatta day with very little wind. One *nabby* is registered at Ardrossan (AD) and the other that is visible is from Irvine (IE); both of these ceased being registration ports after 1902. It is thought this might be off Fairlie.

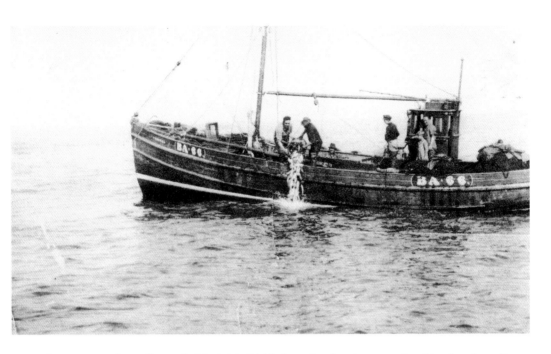

The ringer *Verbena* (formerly *Virginia*), BA66, dumping herring over the side after the collapse in the market in 1946/47.

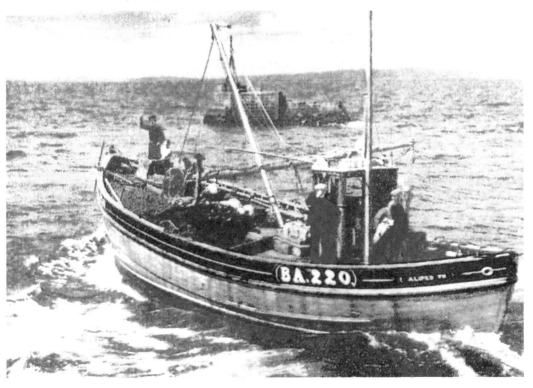

The 'Alipeds' were a series of well-known boats. Here is *Aliped VII*, which was later sold to Carradale and renamed *Amy Harris*. The final one was number IX, built by Alexander Noble in 1964.

A selection of photographs of fishing craft of the second half of the twentieth century seen around the west coast in around 2002.

Mono the dog watching *Corsair*, LH426, leave her mooring in Lochboisdale. Although registered in Knaresborough, which is nowhere near the sea, *Corsair* was owned and based in Girvan. She had been built in Eyemouth in 1965. *Floresco*, SY9, had been built in Arbroath in 1959 and was owned in Barra. Both demonstrate how vessels move from coast to coast, not necessarily working where they were built or owned.

Here's the *Catriona*, TT79, built by Forbes of Sandhaven as the *Taeping*, BA237, berthed in the sea lock at Crinan. Built as a ring-netter/prawner, she was rigged for trawling at the time this was taken in around 2001. Many boats used the Crinan Canal to pass from Loch Fyne to the west coast to save the journey around the Mull of Kintyre, while a few boats moored at Crinan for the weekend, travelling home to Tarbert by road.

Wanderer II, CN142, is another of Alexander Noble's boats built as *Aquila*, OB99, in 1972. Here, she is photographed at Campbeltown with part of the town in the background. She was rigged as a scalloper/trawler and based in Carradale at the time.

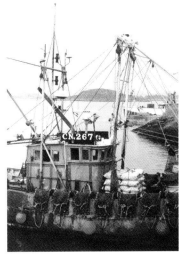

Coral Strand II, CN267, is seen here entering the sea lock at Crinan. Built in Macduff in 1969, she was owned in Ardrishaig and was rigged as a scalloper at the time, the dredges hanging over the side. Bags of scallops sit on the deck awaiting unloading.

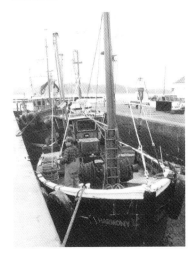

The under-12-m *Harmony*, TT24, was also owned in Ardrishaig at the time and was locking into the canal. She was rigged for trawling, the winch being clearly visible.

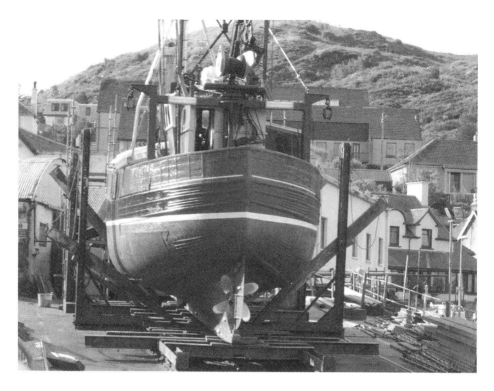

The typical cruiser stern of the Scottish MFV. The boat is *Amethyst*, BA123, built by the Macduff Boatbuilding Company in 1975, and is seen on the slipway at the Mallaig Boatyard. (*Mallaig Boatyard Ltd*)

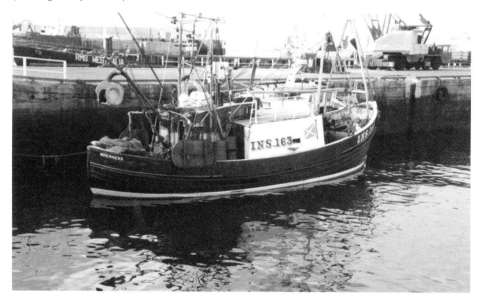

The trawler *Alex Watt*, INS163, is seen here at Lochinver. Built in 1965 at Banff, she was typical of the wooden trawlers of the late twentieth century, with a shelter deck having been fitted at some time after her launch, along with the power block. The otter – or trawl – doors are clearly visible. (*Arthur Roberts*)

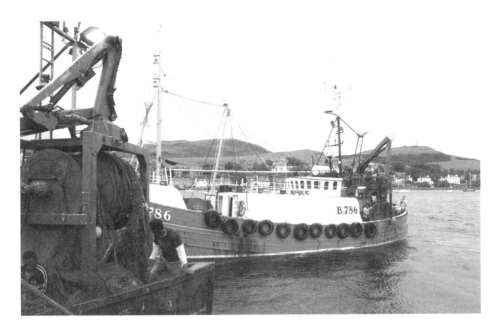

The Belfast-based trawler *Heritage*, B786, coming into Campbeltown in 2011. The shelter deck is much longer than aboard *Alex Watt*, and there's a whaleback over the bow, giving the crew maximised protection while working on deck. The wheelhouse still retains clear visibility although these boats tended to look a bit ugly in comparison with their original state. *Heritage*, as *Moravia*, INS86, was built by Herd & Mackenzie in 1975.

A variety of boats out of the water at Lochinver. The wooden cruiser-sterned trawler *Confide* on the right compares with the wooden transom-sterned trawler *Regent Bird II*, BCK254, on the left. In the centre is a steel boat.

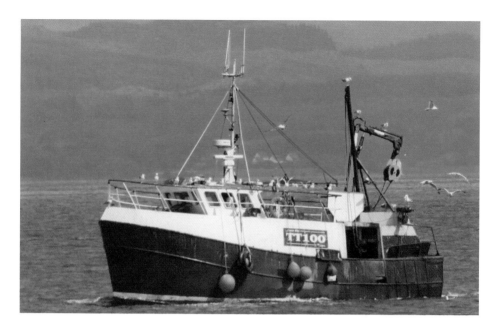

The steel trawler *Nancy Glen*, TT100, was built in Eyemouth in 1991 as a trawler. She has a forward wheelhouse, leaving the covered stern area clear for working the gear. Although the reasons are clear, these boats seem to have become uglier proportionately to the improvement in both efficiency and working conditions. Few people will bemoan the day this boat is scrapped! (*Mike Craine*)

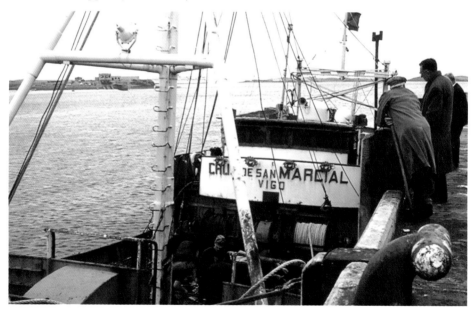

A timely reminder, maybe, that British waters are open to other fishing boats from European Union countries. Here the Vigo-registered *Crux de San Marcial* is alongside in Aultbay, Loch Ewe, in about 1965. Sharp readers will realise that we hadn't joined the Common Market then, but Spanish boats were still able to land in British ports for repairs, stores, etc. At the time they just weren't allowed to fish in British territorial waters. (*Edward Valentine*)

Fishing Folk

Whereas fishing methods and fishing boats are the tools of the fishermen, it is the social history of the fisherfolk themselves that in some ways is the true story of fishing. These fishers survived in their insular communities all strung out along the east coast of Scotland and among the Northern Isles and each had their own traditions and ways of living and fishing. Not until twentieth-century fishing displaced these communities in favour of large ports did these communities change over generations. Son followed father who had followed grandfather into fishing – there was generally no other choice. In far-out regions, especially in Shetland, the fishers were beholden to their landlords, who forced them to fish – the choice was either to fish or be homeless.

Throughout much of Britain, fishing communities tended to be separate from the general populace, often set aside at the end of the town. In Western Scotland the villages were few and far between and the small crofting communities spent much of their time tending the land and only fishing during the warmer parts of the year to supplement an otherwise meagre diet. As we've seen, the British Fisheries Society financed the building of three fishing stations on the west coast at Tobermory, Lochbay and Ullapool though the latter was the only one meeting with some success. On the Outer Hebrides and some of the smaller islands, there was no general finance behind fishing until the late nineteenth/early twentieth centuries.

But communities weren't just about fishing. The boats had to be built, as we've already seen, and the west coast was home to several itinerant boatbuilders who would travel to a particular settlement to build a boat for some individual. Boatbuilding yards – or more likely available waterside fields – spread in the nineteenth century so that a whole host of builders were producing small skiffs. Sailmakers and blacksmiths contributed, as did the various net-makers. Once the fish was landed it had to be either sent straight to market or hawked about the locality or processed. Processing usually involved a either salt-cure or smoke-cure until the advent of refrigeration, deep-freezing and processes such as fish-finger production.

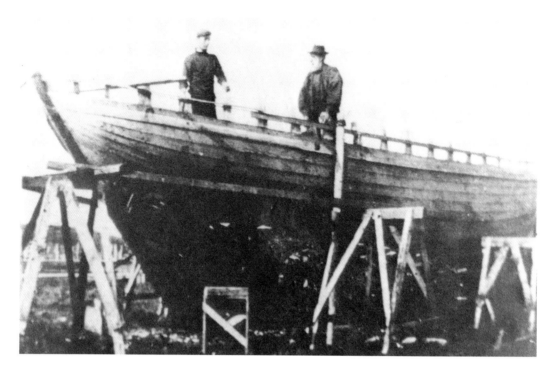

Boatbuilder-cum-fisherman Matthew MacDougal, along with his son Alasdair, working on a skiff they were building in a field behind his home at Port Righ, Carradale, in around 1905. MacDougal was responsible for building a so-called Campbeltown lugger. Campbeltown luggers were luggers that had been brought in from Cornwall, mostly notably from the boatbuilder William Paynter of St Ives and Kilkeel. They were generally used for the Kinsale mackerel fishery off the coast of Southern Ireland and were deemed unsuitable for the ring-net fishery. Some were later adapted as overnight sleeping places for fishermen away from home.

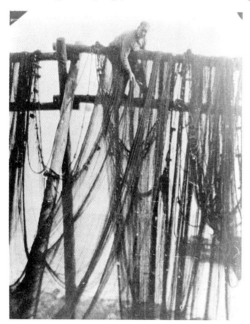

The care and sorting of the nets occupied a great deal of the fishermen's lives. Donald McIntosh of Carradale is atop the poles at Port Crannaig, hanging out a ring-net in around 1930. Nets were hung up on poles to dry, for if they remain damp the action of the seawater rots the cotton. Before cotton, nets were made from hemp and flax though, in turn, cotton was superseded by manmade materials. (*D. McIntosh*)

These three photos show the process of taking a ing-net ashore in Tarbert harbour, 1910. In the top image, Duncan Blair and another are starting to lift the net. In the middle image, the net has been placed into a smaller punt. In the bottom image, it is all ready to be taken ashore.

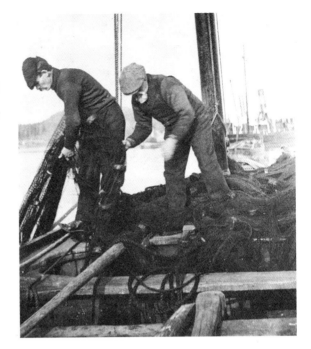

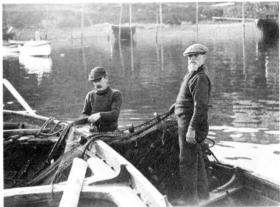

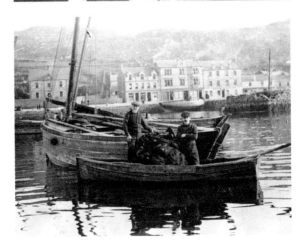

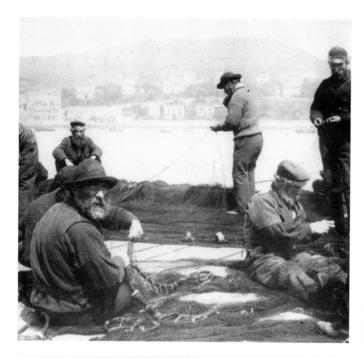

Campbeltown fishermen mending their nets on the New Quay in around 1900.

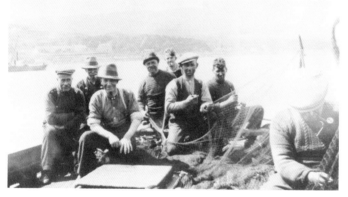

Fishermen aboard the Loch Fyne skiff *Perseverance* off Waterfoot, Carradale, mending nets. The owner/skipper of the boat, Archie Mathieson, is in the middle of the group, fourth from left.

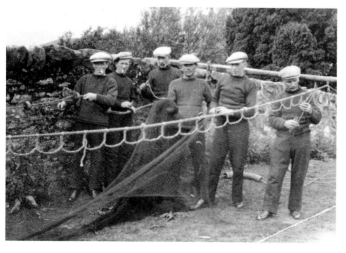

Setting up a ring-net. Here a group of fishermen are making up a ring-net. A complete net is a series of small net sheets weaved together with foot and head ropes fixed on, lead weights along the bottom and floats along the top edge. Furthermore different mesh nets are used so that the bag where the fish eventually end up has a smaller mesh size than the wings of the net.

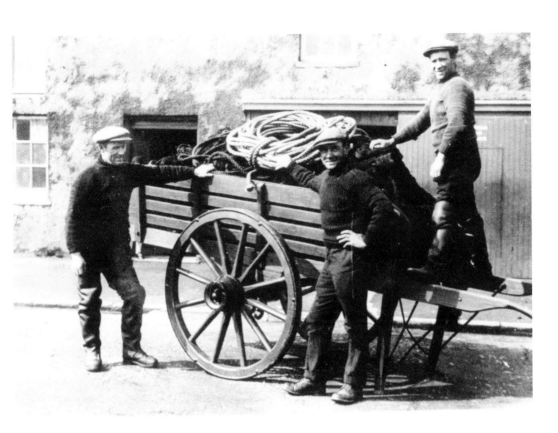

Nets and ropes were generally moved about by cart before the motor vehicle blessed our roads. Here is a group of Campbeltown fishermen moving their gear from or to their boat, perhaps in readiness to bark them.

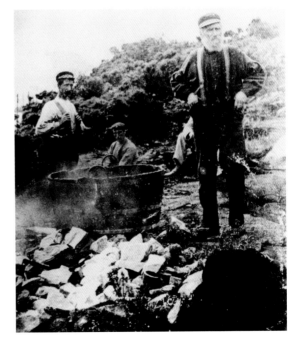

Barking was the process by which nets and ropes were steeped in a solution of tannin to preserve them from the rotting action of the saltwater. Before around 1840 oak bark was used. The bark was soaked in hot water for some time in a tub placed over a fire, as here at Castleton, Loch Fyne.

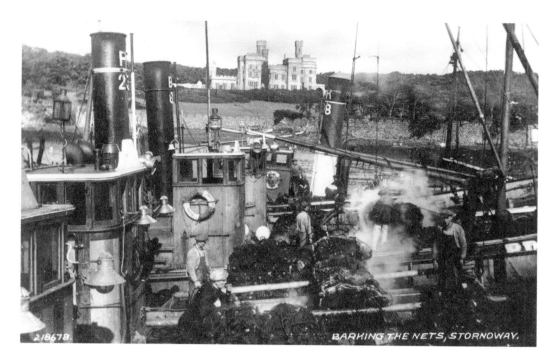

Barking nets at Stornoway. Once the solution was ready the net was placed into the solution and left until hauled out and hung out to dry. The process might occur two or three times a year. Nets were washed in between and always dried after every prolonged use.

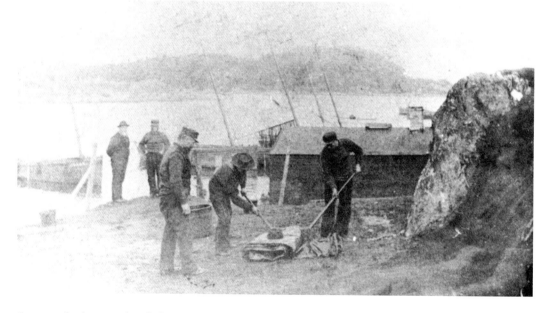

Cotton sails also rotted with dampness and through ultra-violet breakdown. To prevent premature decay the sails were tanned in a similar solution to the nets though often colouring was added in the form of ochre. Fats and salt helped the tanning solution to hold and some fishermen used items such as rancid butter, urine and even dog faeces to do this. (*Maggie Campbell*)

58

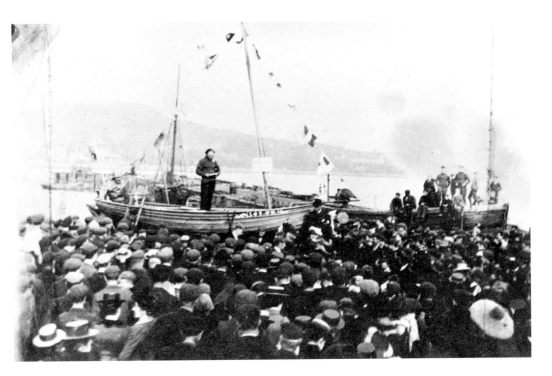

The *Rescue*, CN147, being presented to Dugald Muir (in stern of skiff) at Wylie's Yard in Campbeltown after the skiff was built by public subscription. His earlier skiff was wrecked during a rescue aboard the *Davaar* in 1895. The notice read: 'Presented to Dugald Muir by his fellow townsmen in recognition of his valuable services rendered saving lives.'

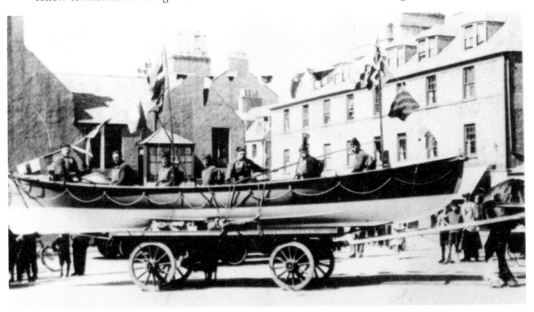

It's worth remembering that in most parts of the British coastline much of the crew of the local lifeboat was made up by fishermen. Here is the Campbeltown lifeboat, with the crew posing for a photo.

Regatta rig at the Campbeltown regatta. The skiff is the *Good Hope*, CN68, skippered by Hugh MacLean, with sails specifically for racing. The annual regatta was a closely fought event, with fishermen preparing their boats by scraping and painting the bottom beforehand and sometimes having a special regatta rig of sails. *Good Hope* was built in 1906 by Duncan Munro of Inveraray and sold to Stranraer in 1934.

The skiff *Mary Graham* in Saddell in 1919 during the regatta day with a full complement of passengers. The skiff was built by James Fyfe of Port Bannatyne in 1901. (*Angus Martin*)

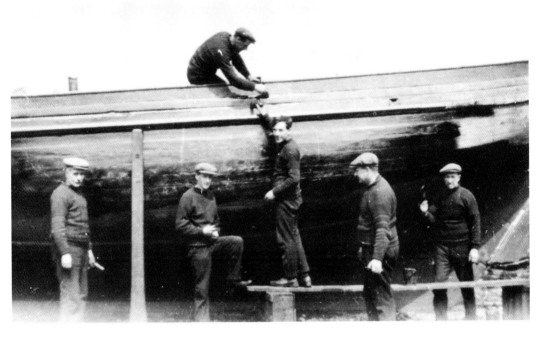

Scraping and painting the hull of *Fame*, a Dalintober skiff. Left to right: Duncan Martin, James Martin, Angus Martin, John Martin, Kenny Martin and on deck John MacAulay. (*Angus Martin*)

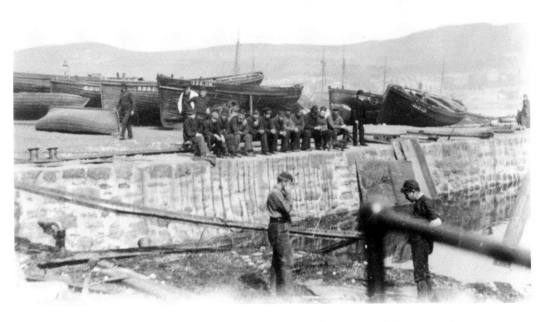

Clinker skiffs drawn on the quay at Campbeltown. Fishermen tended to gather in groups and here they are maybe discussing the state of the fishing while the fellow on the slip looks like he's on a mobile phone!

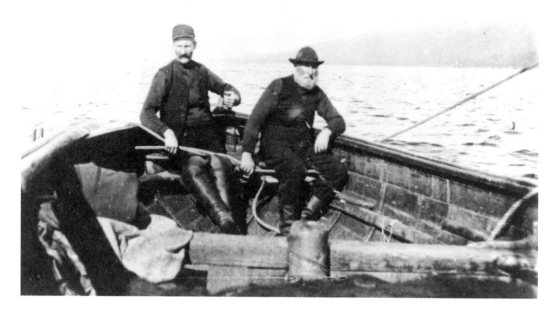

Two men in a skiff at sea. The helmsman on the left is holding the sheet from the mainsail through the gunwale while the man on the right has added security by sitting on it and holding the end of the bight on a downwind sail.

Archie Mathieson aboard the skiff *Perseverance*. This would have been in the 1920s, after the addition of the pillbox wheelhouse. (*Kate McWilliam*)

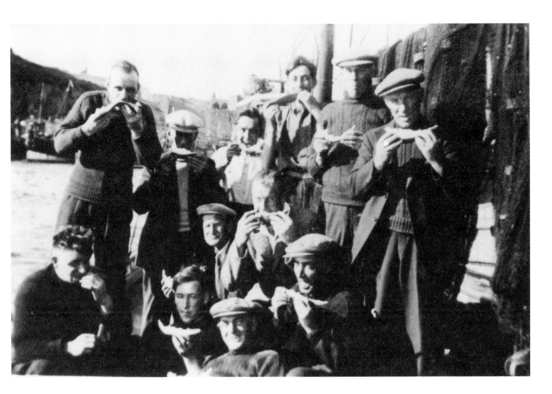

Campbeltown fishermen having a feast on melon at Whitby. The west-coast fishers travelled through the Forth & Clyde Canal in their traverse to the east coast.

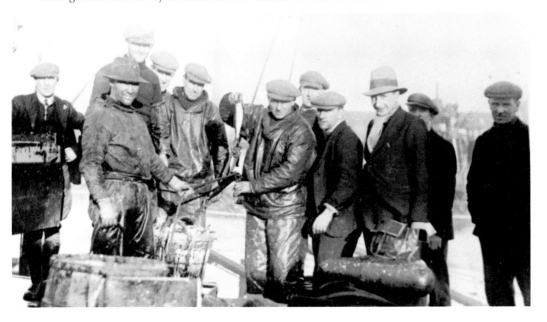

Fishermen showing off the quality of their catch to fish dealer and seller David Robertson, third from right. Second from the left is Archie 'Baldy' Stewart. The dress gives a good impression of the oilskins and general clothing the fishermen used in the first half of the twentieth century. (*Angus Martin*)

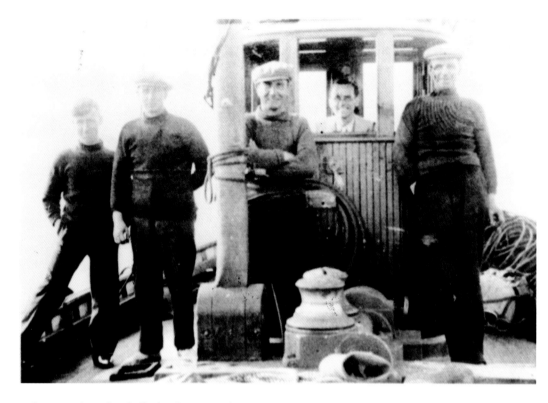

Fishermen aboard a skiff. The drum winch was a vital part of hauling in the ring-net. Before, it was sheer hard graft. Note the low bulwarks, which allowed the ring-net to be worked from the deck, especially when brailing the herring aboard. (*Angus Martin*)

Renowned as the most innovative fisherman on the west coast, Robert 'Hoodie' Robertson, pictured here, was the first to install an engine into his skiff, the person responsible for the introduction of the canoe-sterned ringer and a pioneer of the modern ring-net. (*Angus Martin*)

Around the Coast

Decent harbours were few and far between along the north and west coasts. In the late nineteenth and first half of the twentieth century small piers were built at what had previously been inaccessible parts of the coast and a part-time fishery developed. Along the north coast these piers enabled boats to have a modicum of shelter at John O'Groats, Gills, Harrow, Castletown, Sandside, Portskerra, Bettyhill, Skerray, Skullomie, Ard Neackie, Portnancon and Rispond. On the west-coast islands, there are numerous such piers built to encourage tiny crofting communities such as those built by the British Fisheries Society and others, while more substantial quays developed at Mallaig, Tarbert and various parts of the east side of the Clyde; Campbeltown was regarded as being one of the most sheltered harbours in Scotland. In more recent times Scrabster, Kinlochbervie and Lochinver were landing ports for huge quantities of fish from, often foreign-registered, vessels, the fish of which went by container straight to the Continent.

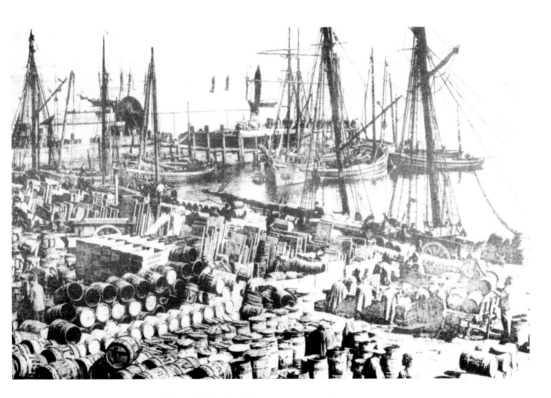

The Northern Coast – The Pentland Firth to Cape Wrath
Scrabster harbour when herring was being landed in large quantities. The barrels were taken to the railway at Thurso and distributed throughout the country or by schooner to various points on the globe. The harbour dates back to Viking times, though the present quays were built in 1841 to harness the ferry service to Orkney. More recently, its proximity to the northern fishing grounds created a landing of fish which was usually sent straight to the Continent.

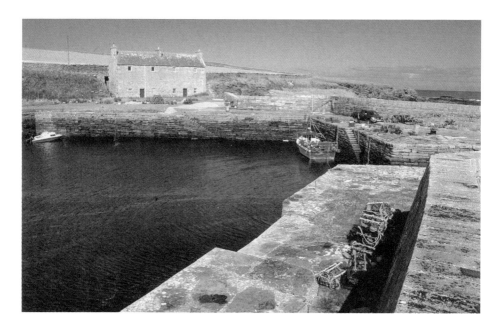

The harbour at Sandside – sometimes called Fresgoe – was built to import goods to the nearby estate at Sandside House as well as to encourage fishing, by Major William Innes in 1831. It is said that the house at the harbour was once the Fresgoe Inn, run by French girl Mary Moss who had married locally. French and Dutch crews often called in as she was fluent in both French and English. Today the harbour is used by a couple of creel boats and pleasure anglers.

Skerray harbour was built in the late 1890s for the nearby crofting and fishing community. It is said that twenty-five boats once worked from the small harbour, the pier of which was funded by the Duke of Sutherland. Today it is home to a few part-time fishermen, mostly setting creels.

The Outer Hebrides – Lewis to Barra

Stornoway harbour around the turn of the century. The first quay was built towards the end of the eighteenth century, though in 1786 John Knox noted that vessels were still unloading on the beach. Further harbour facilities were built in the middle of the nineteenth century and it was again extended to allow steamers to land. A substantial fishing fleet is in harbour in this photo, dated around 1900.

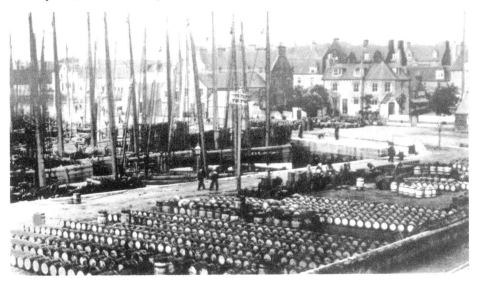

Herring barrels on the quay at Stornoway. The population of the town trebled and, in 1899, it was reported that there were 930 boats in harbour. Cured herring was taken to the railway head at Kyle of Lochalsh by steamer on the journey to Billingsgate or by ship to the markets in Eastern Europe. The industry did survive between the wars, although on a much-reduced scale, and after 1945 gradually disappeared.

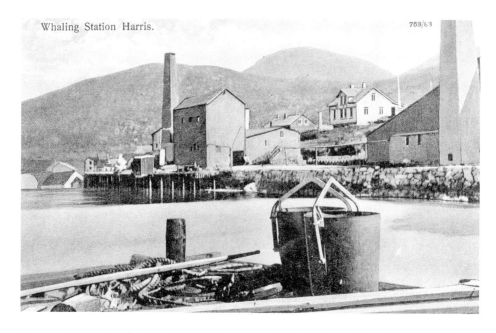

In 1903 a Norwegian family – the Herlofsens – ran this whaling station at Bunavoneader on the south-west coast of Harris. Lord Leverhulme then bought the site from the Norwegians in 1920 and had ideas of cutting a canal through the isthmus at Tarbert, though he died before this could be done. The station opened briefly once again in the 1950s, when whales were processed locally. However, that enterprise only lasted three years and today part of the site remains as a Scheduled Ancient Monument. (*Campbell McCutcheon*)

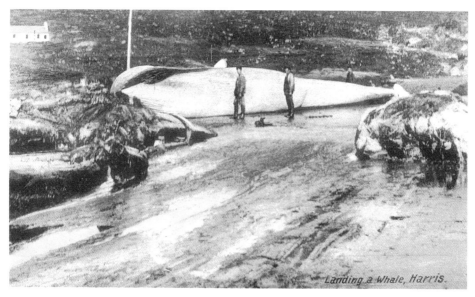

Landing a Whale, Harris.

Whales were at first landed near to wherever they were caught as, for example, in St Kilda. The oil and blubber were then brought back to the whale station for processing and exporting. In the 1950s all the work was carried on at the station, as in this photo from *c.* 1905 where a whale has been landed, although this looks more like a stranded whale than a caught one. (*Campbell McCutcheon*)

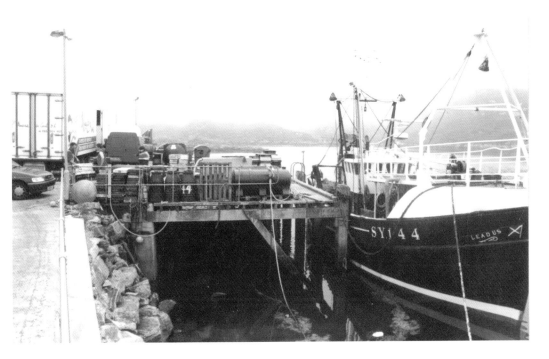

The small pier at Stockinish on the south-east coast of Harris where fishing boats can land. The trawler *Lead Us*, SY144, was unloading at the time this photo was taken in 2003. The fish went into the container lorry there, which was Spanish registered, and presumably straight off to the Spanish consumer. Much of British fish goes this way.

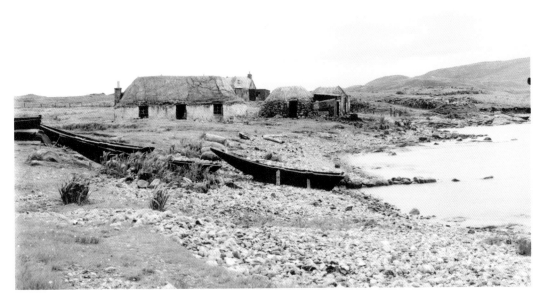

A currach on the Western Isles. Although the site of this photograph is unknown, it does show that currachs were in use in some of the inaccessible places after the introduction of the camera in the nineteenth century. The boat on the extreme left, however, is wooden.

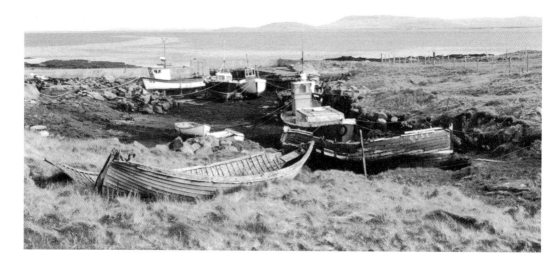

One of several of the tiny inlets on the east side of the Outer Hebrides where small boats find shelter. These in time become halfway between a graveyard of decaying vessels and an active working harbour.

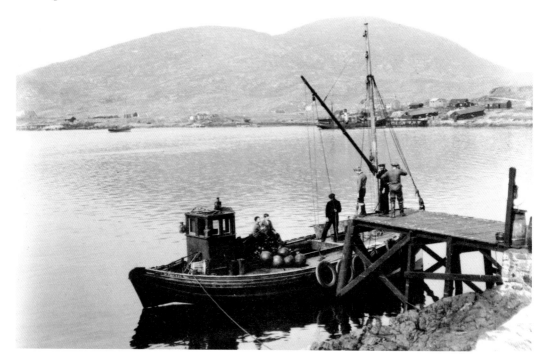

Unloading at Castle Bay. The boat is a small fifie/seiner type from Mallaig, probably landing herring. Castle Bay, in Barra, has a wonderful naturally protected harbour and was the centre of a healthy herring fishery in the latter part of the nineteenth century and early twentieth. The steamer in the background might be landing herring into what looks like a herring station, although it might be loading to carry cured herring to the mainland.

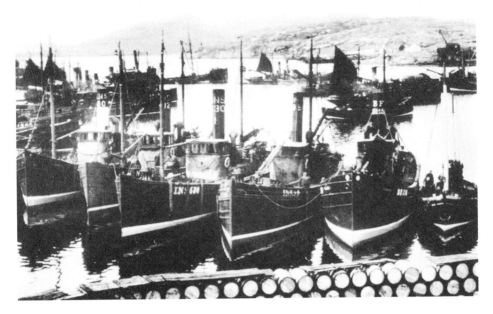

Castle Bay again, at the height of the herring fishery, when up to 400 boats would land there. The bay was dotted with fishing stations and a variety of sailing and steam vessels landed. Here the vessels are mostly steamer drifters from the east coast of Scotland – notably Inverness and Banff. Herring barrels line the shore.

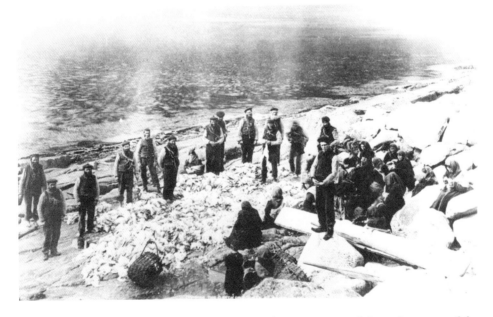

Sharing the catch of fulmars on St Kilda in around 1880. Because of the rocky nature of the coast, fishing was impossible throughout most of the year. The inhabitants – numbering less than 100 after 1851 but seldom over 180 before that date – tended to eat birds such as fulmars and gannets. They also kept sheep for the milk, ate birds' eggs, grew barley and potatoes and collected limpets off the rocks.

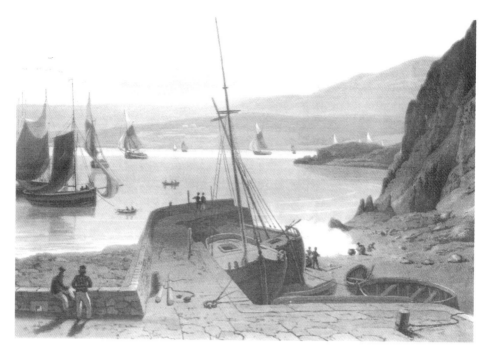

Cape Wrath to the Isle of Skye

The pier at Tanera Mor by William Daniell about 1820. Tanera Mor was the home of one of the large herring-fishing stations on the west coast. The pier was built by the British Fisheries Society and, according to Daniell, upwards of 200 vessels might be seen at anchor. The remains of the old curing station can still be seen on the island.

Four views of Ullapool in the late nineteenth century follow.

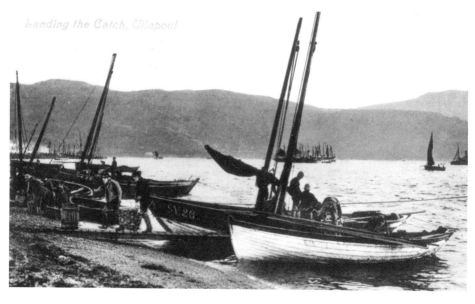

Landing the Catch, Ullapool

Small boats – *bata* – landed the catch, which was carried ashore in baskets.

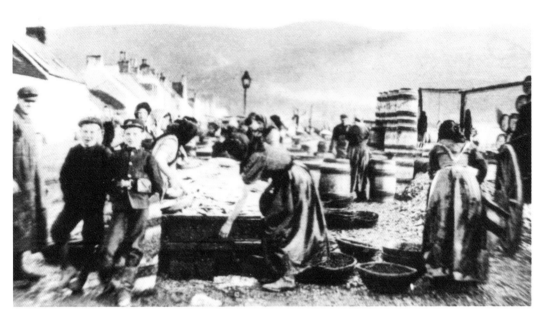

This was then tipped into the *farlane* (gutting trough), which was set up between the beach and the houses, on what is the road today.

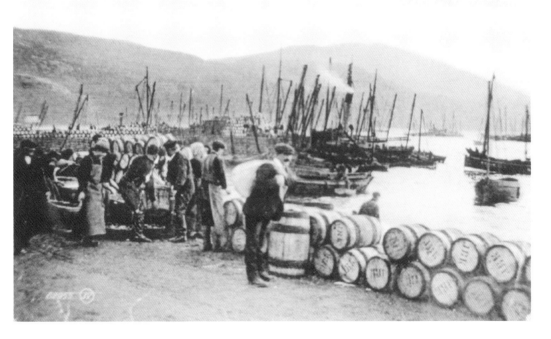

Once gutted and salted, the barrels line the quay ready to be exported, possibly aboard the steamer.

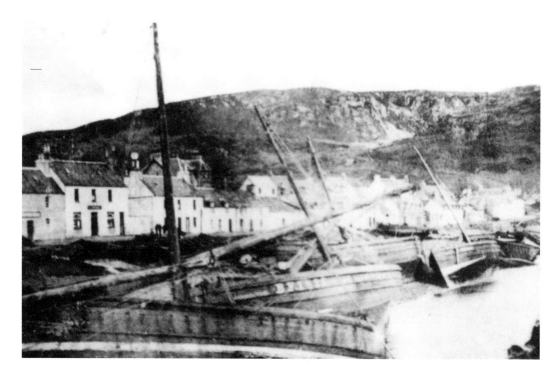

The fishing fleet at Ullapool suffered severe damage during a gale in January 1905. All fishing fleets were constantly at the mercy of the weather until harbours were built around the country.

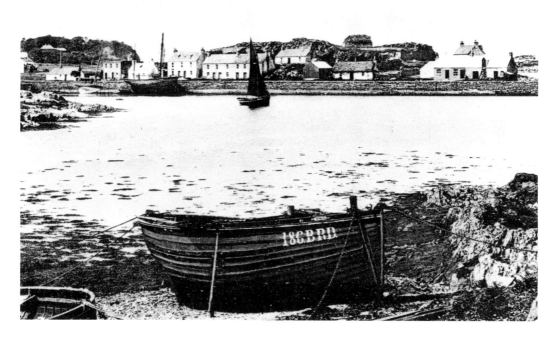

Kyleakin, on Skye, was the crossing point to Kyle of Lochalsh on the mainland. BRD is the fishing registration for Broadford, a few miles along the coast.

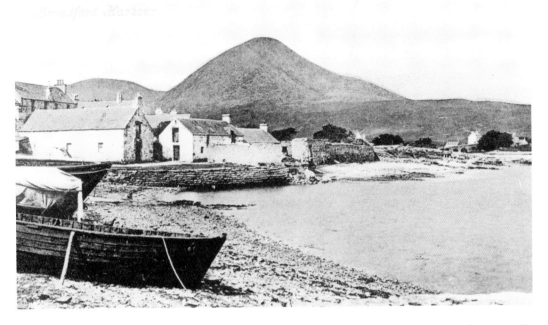

You'd be forgiven for thinking Broadford was little more than a tiny settlement with an equally tiny drying quay. However, it was regarded as the base for the local fishing industry, even if the boats landed elsewhere.

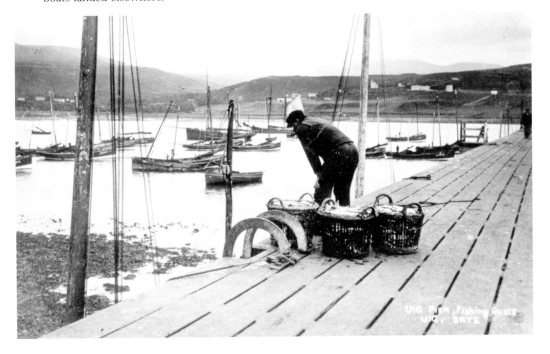

Uig, on Skye's north-west coast, is today home to fishing vessels as well as the terminal for the ferry to Lochmaddy. It sometimes gets confused with Stein, on Lochbay, which is also referred to as Uig and which was built by the British Fisheries Society.

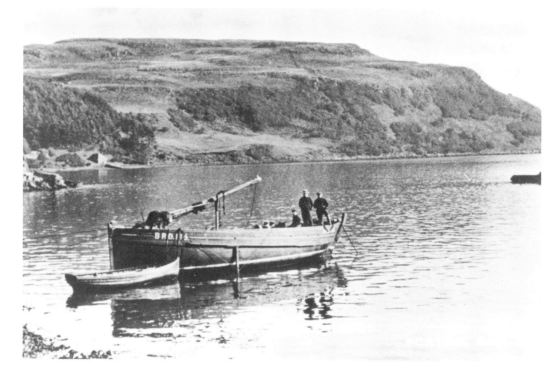

Skiff at Portree. As we've seen in a subsequent chapter, the design of boat was similar all along the west coast and is generally referred to as the Loch Fyne type.

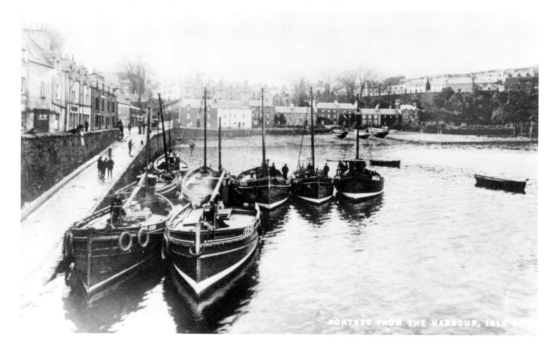

Portree became a base for boats from Campbeltown during the northern herring season. Most of these are CN-registered, except for the outer one on the biggest trot, which is from Broadford.

Mark Stockl builds and repairs boats in Ullapool today, here at his workshop a few miles outside. The boat in the centre is *An Sulaire*, the Ness *sgoth* from Stornoway which was in for repairs to the thwarts in 2011. The red boat is a coble and Mark was starting building a small clinker boat in the shed at the time.

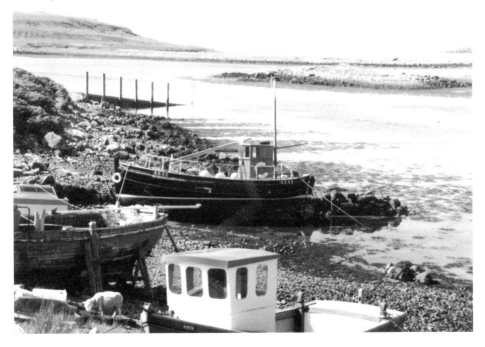

Old fifie at Old Dornie, which is a small sheltered bay on the channel between the mainland and the Isle of Ristol. It is also the final resting place of many old working boats.

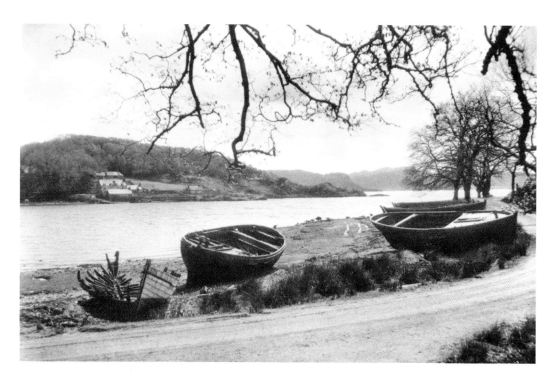

Flowerdale, a small inlet just south of Gairloch itself, today has a pier where fishing boats can work off. Although the house across the loch still exists, Flowerdale – known today as Charlestown – is a very different place today from what it was when this photograph was taken in around 1910.

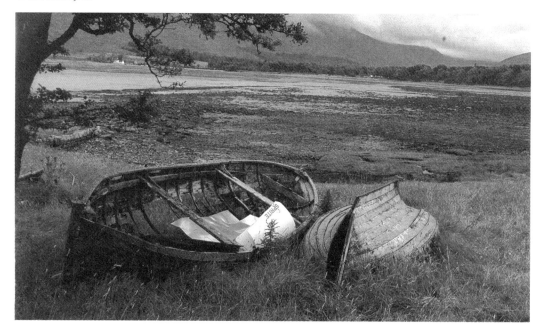

Boats at Applecross, 2011. Although similar to the boats in the last photo, few are used today except for pleasure.

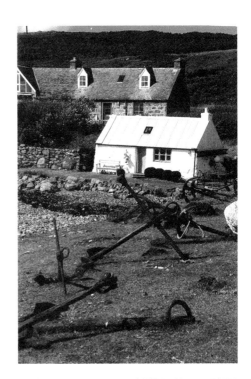

Anchors at Achiltibuie. Today, much of the maritime past of the British coast is reflected in artefacts left in timely places. Note the buoys hanging from the cottage walls.

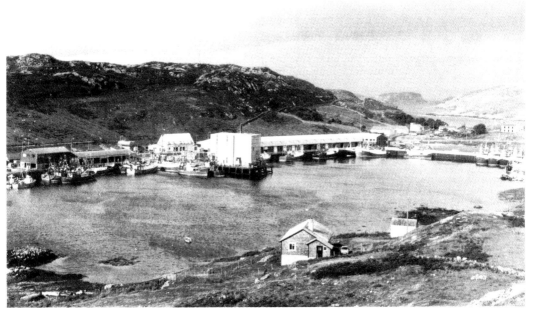

Kinlochbervie. The pier dates from 1961, when the North Minch grounds were being fished by boats from outside. Aberdeen fish-seller Wood Group moved in in 1971, when the harbour entrance was widened and an ice plant built. In 1983 13,500 tons of fish were landed. By then plans were afoot to enlarge the harbour and the new pier was opened by Prince Charles in 1988. Nowadays the port is probably used more by pleasure craft than fishing vessels, even after the huge financial input to the area, which included widening the main A894 road to cope with the heavy container traffic.

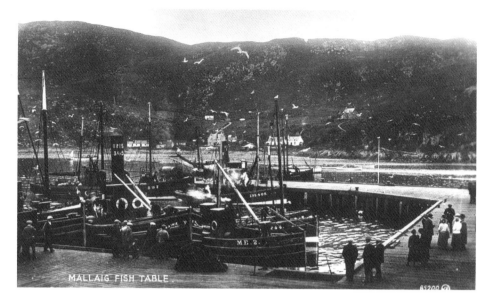

The Isle of Skye to the Mull of Kintyre

Four views of Mallaig. Mallaig is a relatively new town which dates from around 1840 with the dividing up of the Mallaigvaig farm into seventeen parcels of land, encouraging the locals to move towards the sea and take up fishing. By the end of the century, fishing was successful, as shown here with sailing boats and steam drifters in harbour. In 1882 there were two steamers sailing to Oban daily with fish. Around the harbour were several smokehouses and the herring lassies came here during the season. (*Campbell McCutcheon*)

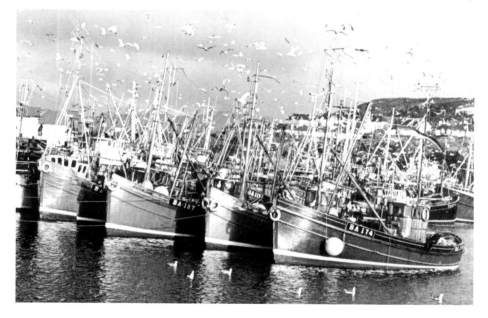

Mallaig in the 1960s, when the town was described as the 'busiest herring port in Europe', although this does sound slightly tenuous and it appears not to have been the only port thus described over the years. Bumper catches did bring wealth and an abundance of boats. (*Peter Brady*)

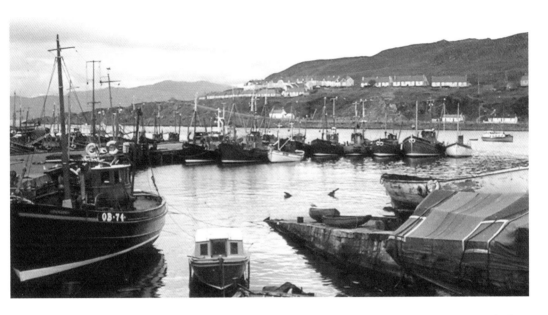

By the late 1970s the herring bonanza was over. This fleet of boats was probably one of the last. Today Mallaig, as elsewhere, relies mostly upon the prawn fishery. (*Edward Valentine*)

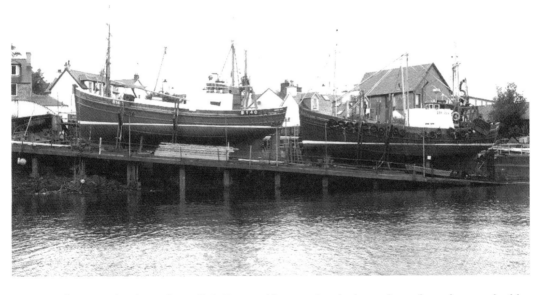

Two boats on the slip at the Mallaig Boatyard in 2012. Rarely do two boats from the same builder appear next to each other but here is *Ribhinn Donn II*, B140, (1973) on the left and *Silver Dawn*, OB333, (1970) both from Noble's of Girvan. Today Mallaig Boatyard Ltd operate the slip by the harbour and appear to be pretty busy these days, hauling out west-coast fishing craft for repairs and overhauling. (*Mallaig Boatyard Ltd*)

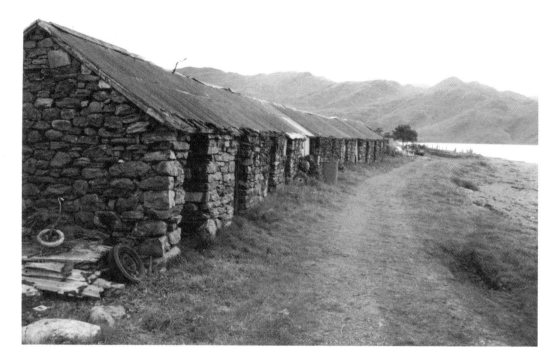

The old curing houses and fishermen's cottage at Loch Hourn. At the end of a long road to nowhere, the erstwhile traveller arrives at Arnisdale, on the edge of Loch Hourn. Here a vibrant herring fishery existed in the early nineteenth century. Today the buildings still remain but little other forms of life exist in this inaccessible part of the coast.

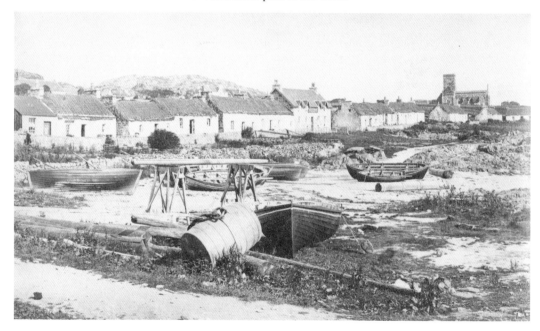

Boats lying on the beach at Iona. All are of the west-coast type and appear to be line boats working around the island and over to the other nearby islands and Mull.

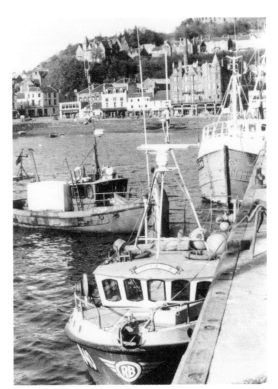

Oban in the 1990s. The local fleet consisted mainly of creel boats and light trawlers that used Oban's new facilities, which were opened in 1990. Again, prawns figure mostly in the catch.

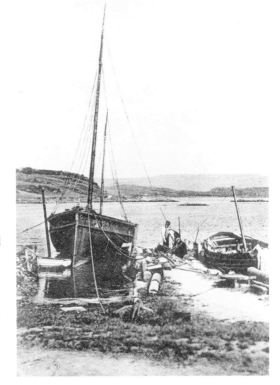

Loch Fyne and Kintyre
Tayvallich Bay from the post office. Tucked away on Loch Sween, a few miles south of Crinan, Tayvallich offered a perfect sheltered harbour for fishing. The two-masted boat on the left has KY on its bow, suggesting it is from the east coast, but the photo illustrates how such a small hamlet would have been in the late nineteenth century, with three fishermen working on something or other.

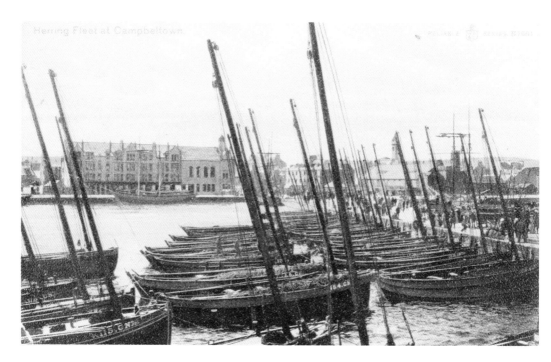

The fleet at Campbeltown in the late nineteenth century. The boats are all Loch Fyne skiffs, recognisable by their raking masts. The nets lie in the boats and await the next outing.

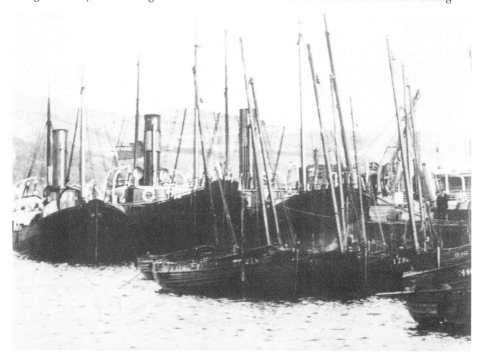

Campbeltown again, with small clinker-built skiffs in front of the so-called herring screws *Nightingale*, *Rob Roy* and *Talisman* at the Old Quay. These herring screws carried the herring to market in Glasgow. (*W. Anderson*)

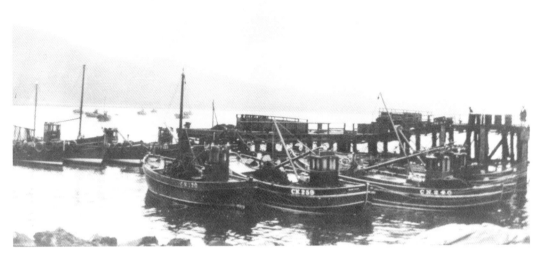

Carradale pier *c.* 1950. Carradale has been a popular harbour for local fishermen though it has been modernised since this photo was taken. Today it is home to no more than a handful of boats, a far reach from when it was crowded with ringers. (*Naomi Mitchison*)

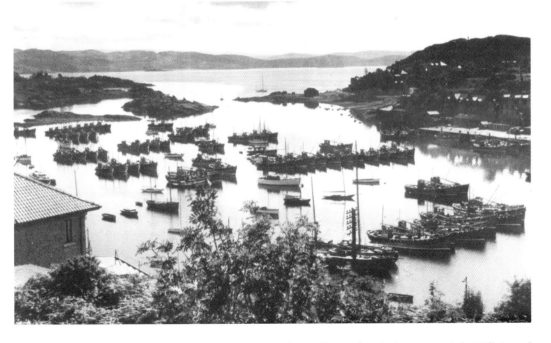

East Loch Tarbert in the 1950s, with ring-netters from all over the Clyde, Moray Firth, Mallaig and the Lothians moored up. Boats used to moor at West Loch Tarbert, a mile away from the village across the narrow isthmus that almost separates the Kintyre peninsula from the mainland. (*Peter Brady*)

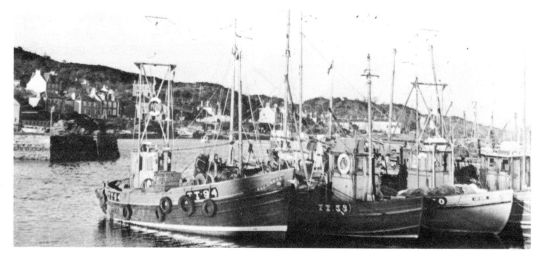

Another view of boats at Tarbert in the 1960s. (*Peter Brady*)

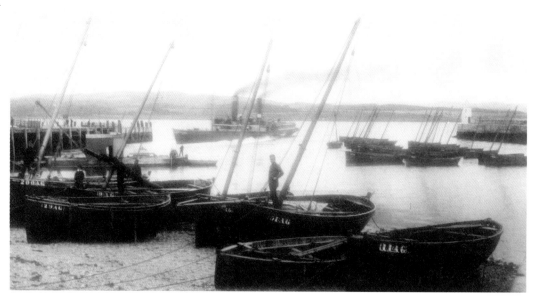

Small skiffs at Ardrishaig. The lighthouse on the right is at the entrance to the Crinan Canal and the paddle steamer is the ferry to Glasgow.

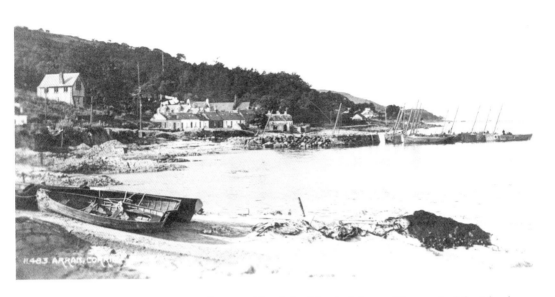

Skiffs moored up at Corrie on the east side of the Island of Arran. The coast of the island was home to several small fishing communities, such as at Pirnmill, Loch Ranza and Blackwaterfoot on the west side. Often, boats from the Kintyre fleet would moor at one of these quays to rest or collect food.

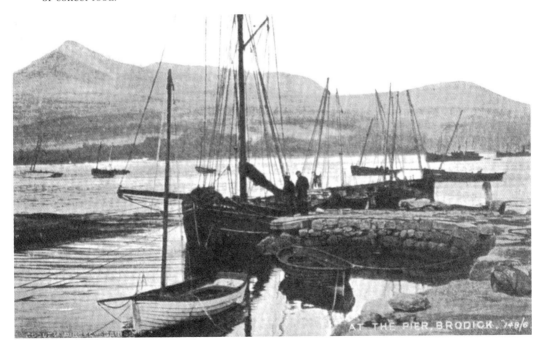

Brodick Bay was another such place where boats could anchor off in shelter from the prevailing wind. On the quay a trading smack is perhaps resting after unloading.

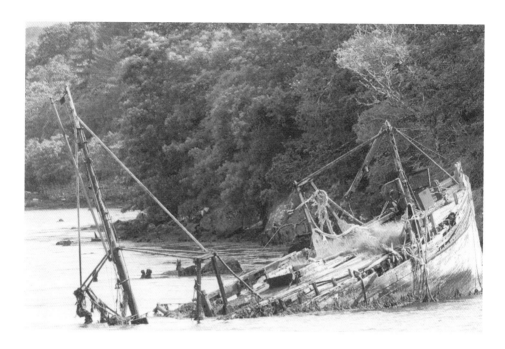

Many a fishing vessel has ended its life stranded upon the shoreline and left to rot. This boat, *Enterprise*, FH181, was photographed at West Loch Tarbert in about 2007. (*Mike Craine*)

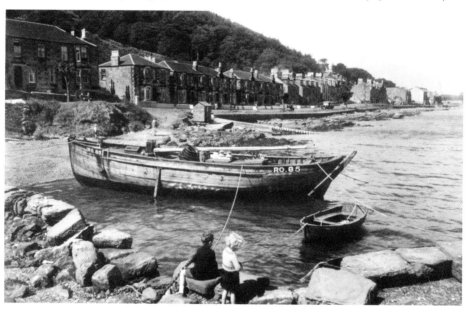

The Clyde to the Solway Firth

This view of Kilchattan Bay, Isle of Bute, shows a Loch Fyne skiff moored close to the odd pier. The registration RO is for Rothesay, where a number of boats were based. Port Bannatyne, around the bay from Rothesay, was home to James Fyfe, a prolific builder of the skiffs. There were, in fact, four members of the family building boats – Robert at Ardrishaig, Thomas at Tarbert and Dan who moved from Paisley to Tarbert, then to Stranraer. All were related to the Fifes of Fairlie, who were also renowned racing-yacht builders.

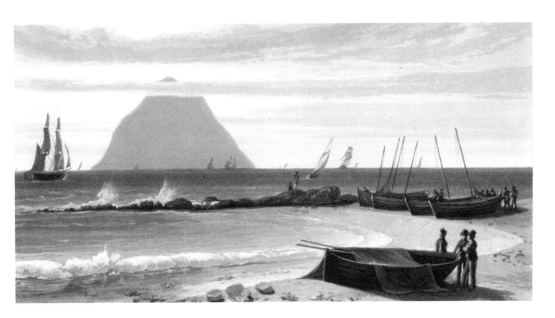

William Daniell's print of Ailsa Craig with double-ended skiffs on the beach. These, it is said, were introduced into Ayrshire by a fisherman from the east coast and so impressed the Loch Fyne fishers that they, too, adopted the double-ended skiff for their line fishing. These eventually led to the Loch Fyne skiffs.

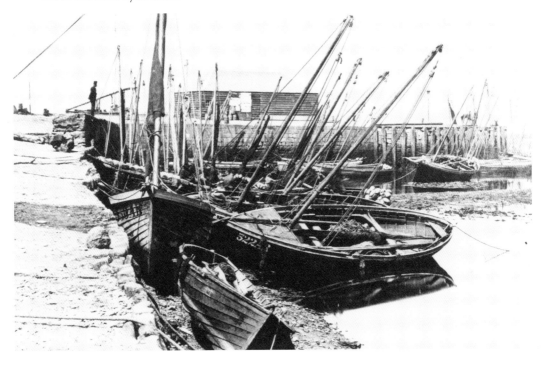

Irvine, towards the northern end of the Clyde coast, had its own fleet of boats – these being called *nabbies* as against skiffs on the west side. The word *nabby* has been said to have originated from the east coast, with others suggesting it as a local form of *nobby*, as the boats used by Cumbrian, Manx and Lancashire fishermen were called.

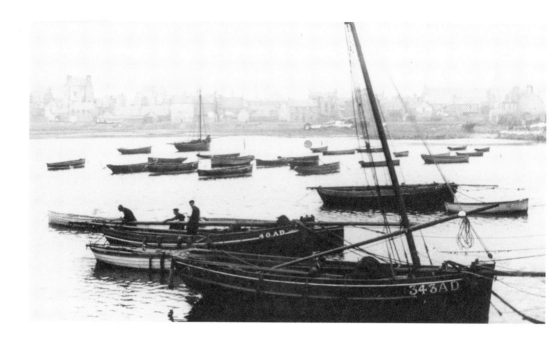

Troon, too, had a small fleet, these being registered at Ardrossan. The boat in the foreground is interesting as it has a transom stern with the standard raking mast and standing lug sail. It's hard to determine but the boat with the men aboard also appears to have a transom. Saltcoats, Ardrossan and Ayr had their own fleets too.

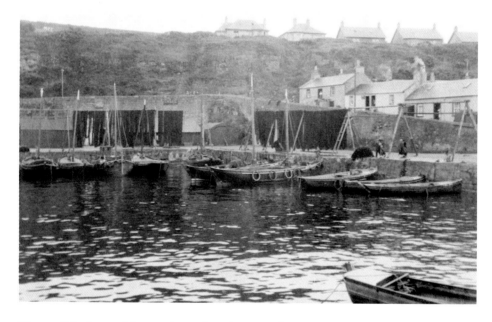

The small harbour of Dunure is a relatively new village, dating from the early nineteenth century. The harbour was built in 1811 and within a few years was being used by fishermen and the odd trading smack.

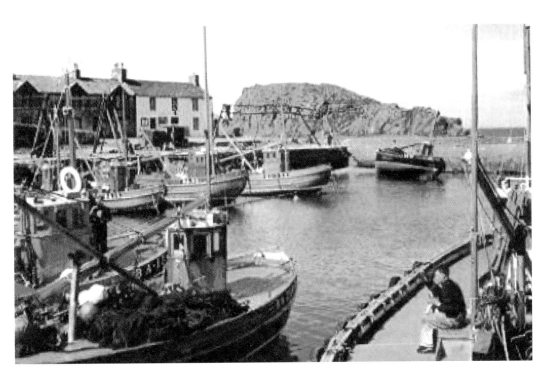

In the twentieth century it became home to a fleet of varnished ring-netters, as this photo from the 1950s shows.

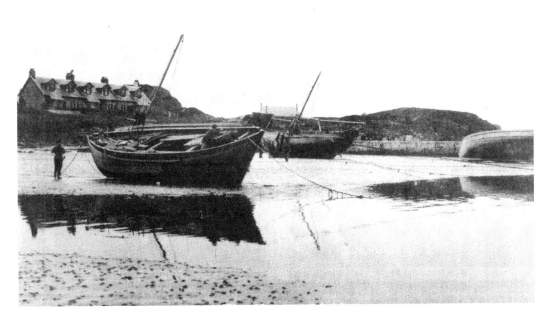

Maidens, across Culzean Bay from Dunure, evolved from a few fishermen's cottages into the home of a substantial fleet. Some say the men from Dunure, Maidens and Ballantrae were the best proponents of the ring-net. Fishermen themselves raised money to improve the harbour in 1953 by levying one old penny on each basket of fish landed by Maidens boats.

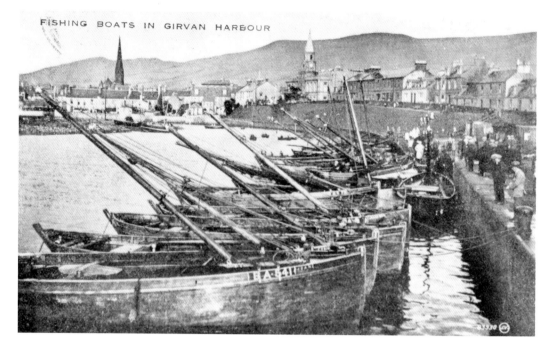

Girvan, situated at the mouth of the Water of Girvan, became an important fishing base in the nineteenth century. Here, the *nabbies* are lined up along the quay.

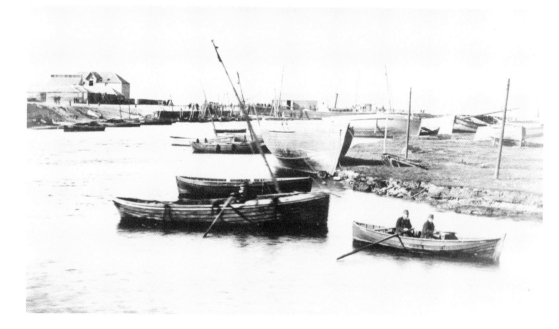

Another view of Girvan, looking down river with *nabbies* moored alongside the quay. The land on the right, on the north side of the river, is where the renowned boatbuilder Alexander Noble built his yard here in 1946 after being made aware that there were no facilities in Girvan. He originated from Fraserburgh where he had his boatbuilding training, worked in Killbegs and then Rosneath, before setting up with his son James.

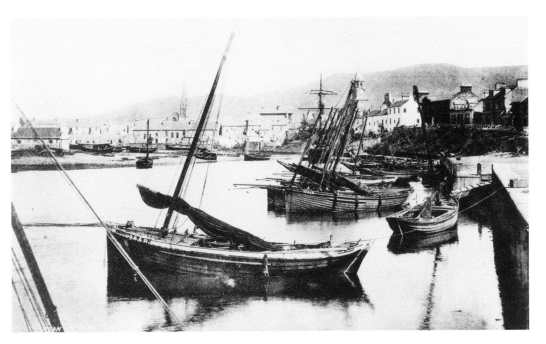

Girvan looking upstream, the opposite way to the previous photo. The Noble's yard was to be built on the left of the river, which even in 1946 was a green field site. Initially boats were built in the open but gradually sheds were constructed. The yard survives today, undertaking repair work.

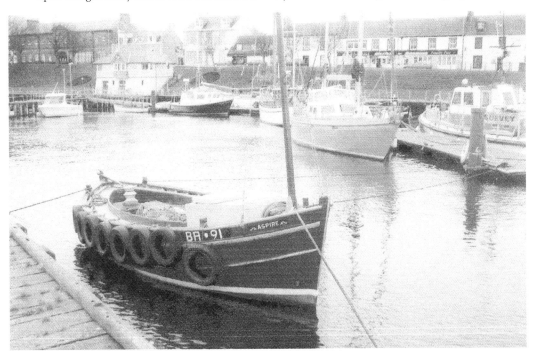

The small creel boat *Aspire*, BA91, was still working up to a few years ago. This is typical of the east-coast creel boats that were built by Millers of St Monans and Smith & Hutton of Anstruther.

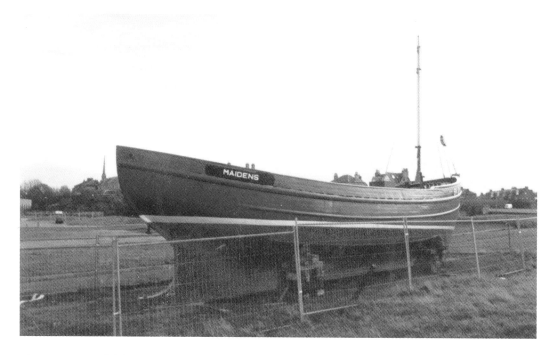

The ringer *Watchful*, BA124, was built by Weatherhead & Blackie of Port Seton in 1959. She neighboured with the *Wisteria* under the ownership of renowned fisherman Matt Sloan of Maidens and was a very successful boat. She was sold in 1971 and was eventually decommissioned in 1994 and put ashore at Ayr as a permanent exhibit instead of being scrapped.

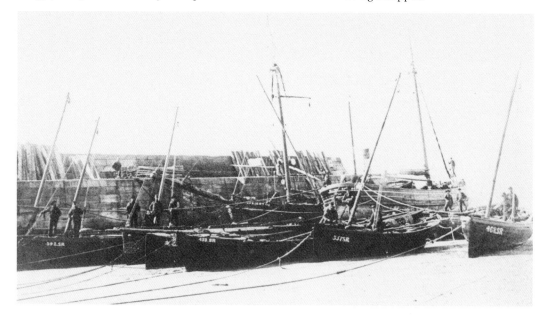

Although only having a short quay, and being described 'about as useful as a chocolate teapot', Ballantrae had a fleet of boats, as shown here in this photo dated around 1880. The boats are registered at Stranraer (SR) and thus this photo predates when Ballantrae got its own registration (BA) in 1902.

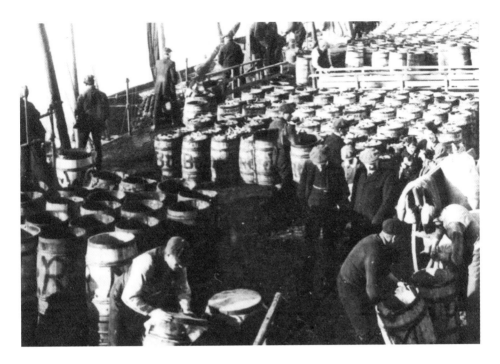

Barrels of herring at Stranraer. Although the harbour dates from the eighteenth century, with improvements made in the 1820s, fishing played little part in the development of the harbour as the ferry crossing to Northern Ireland. However, as the photo proves, herring was landed into Stranraer in the period up to the Second World War.

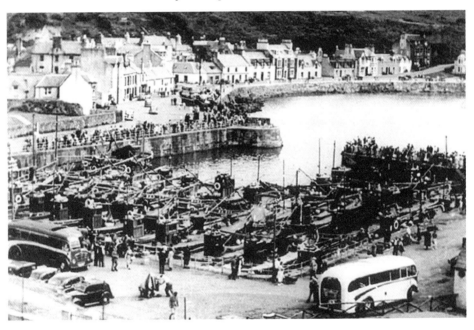

Portpatrick with the fleet in harbour. Although built to harness the ferry traffic, the entrance to Portpatrick harbour can be awkward. Nevertheless, when the herring fleet turned up, it attracted the attention of locals and holidaymakers, as this photo suggests.

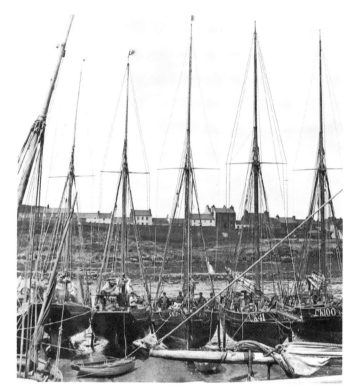

Oyster boats at the Isle of Whithorn. These boats, all registered at Colchester in Essex, roamed the coast in their determined fishing for oysters in the late eighteenth century. We shall see more of these boats in Volume 5 of this series.

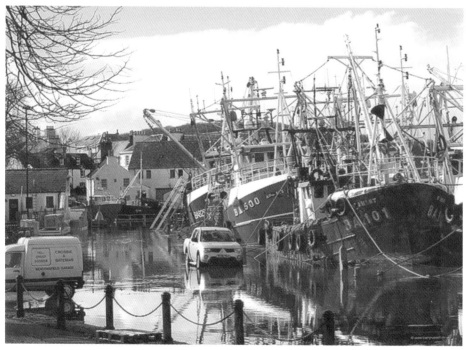

Kirkcudbright, on the Solway Firth, continues, until recently anyway, to be home to a fleet of boats. This photo shows the scallopers *St Amant*, BA101, *Aquinis*, BA500, and *King Explorer*, BA829, moored up. It seemed at times that these larger steel boats dwarfed the town.